Library of Congress Catalogue Number: 00-107156 ISBN: 0-9703425-0-0

Catalogue Editor: Sherrie Flick

Frick Art & Historical Center, 7227 Reynolds Street, Pittsburgh, Pennsylvania 15208

Available through D.A.P. / Distributed Art Publishers, 155 Sixth Avenue, 2nd Floor, New York, NY 10013
Telephone: 212.627.1999 Fax: 212.627.9484

For gaspar

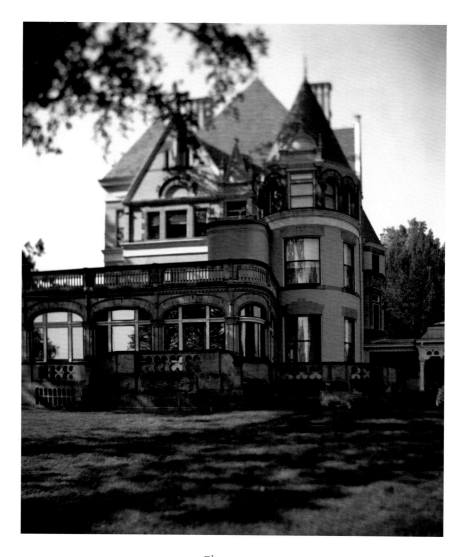

Clayton, 2000

Clayton Days.

PICTURE STORIES *by* VIK MUNIZ,
for very little folks.

———

PITTSBURGH
FRICK ART *&* HISTORICAL CENTER

Beyond interpretation

by DeCourcy e. McIntosh, executive director, frick art & historical center

Clayton was where henry clay frick raised his family, established himself socially, and began assembling his art collection. For all its opulence and incongruities, its fine paintings and oddments of no intrinsic value, it simply manifests one man's rise in the world.

Frick never knew, of course, that Clayton would be embalmed and reincarnated as a museum. That was the destiny his only surviving daughter bequeathed it. As is well known, she self-consciously saved every conceivable scrap of evidence of a little girl's privileged but sometimes troubled childhood within Clayton's protective walls, in the shelter of its great trees. She did this in reverence to her father. On the strength of the evidence, the Frick Art & Historical Center exhibits Clayton as both a specific magnate's residence and, more generally, as a home of members of a class of Americans whose sudden, legendary prosperity at the end of the nineteenth century has fresh parallels in our own day. But Clayton remains the place handed down to us not by Frick but by his daughter, who lived to a very advanced age in zealous possession of her childhood dwelling. And, whether we like it or not, it represents our interpretation rather than her reality, let alone Henry Clay Frick's. No matter how deeply a visitor imbibes Clayton, he remains an observer, separated from historical fact as much as connected to it by the choreography of Miss Frick and the Frick Art & Historical Center. I doubt any visitor to Clayton has ever understood this paradox better than Vik Muniz.

It was a sense of the limitations of historical interpretation that led us to Muniz in the first place. After nearly ten years of impressing upon the public the accuracy of the Clayton restoration and the significance of the site, we craved a fresh perspective, one created not through analysis of historical evidence but formed by the eye and hand of an artist.

Purposely borrowing the initiative of a venerable turn-of-the-century residence-become-museum, the Isabella Stewart Gardner Museum, we established an artist's residency and, on the expert advice of Andy Grundberg and Linda Benedict-Jones, invited Muniz to be our first artist in residence. As if mere acceptance of our invitation were not flattering enough, the artist chose to involve virtually everyone at the Frick Art & Historical Center in his creative process, lending to our work an experience of artistic joy we shall not soon forget.

In his ingenious, puckish way, Vik Muniz has fashioned a life at Clayton suspended between fact and fiction. He teases our sense of reality, subtly invoking our imperfect empirical knowledge of life one hundred years ago to lull us into open-ended reflections on the past — Clayton's and our own. The "Clayton Days" picture stories abundantly satisfy our yearning for genuinely new work that lends new meaning to the experience of visiting the "historic" site.

I would like to express my thanks to Vik Muniz and to his assistant, Cleverson de Oliveira, for their work and for their generosity of spirit. Likewise, to Andy Grundberg for his compelling catalogue essay and to Linda Benedict-Jones for her insightful interview with the artist, I am immensely grateful; from beginning to end, their expertise, intelligence, and conscientious effort have enhanced this project. And of the staff of the Frick Art & Historical Center, who played as well as worked with Vik Muniz, I can only say the result betrays their dedication and good humor.

For The Heinz Endowments, whose financial contribution made this project possible, I harbor the special gratitude and warmth one reserves for those who support one's gambling instincts. Additional funding for the exhibition is provided by Larrimor's, through the courtesy of Lisa and Tom Michael. The Roy A. Hunt Foundation, the Pennsylvania Historical and Museum Commission, and the Allegheny Regional Asset District have partially underwritten attendant educational programs. My heartfelt thanks also go to Brent Sikkema, Michael Jenkins, and Trevor Schoonmaker of the Brent Sikkema Gallery; and to Muniz's colleagues, Renos Xippas and Anne-Marie Russell.

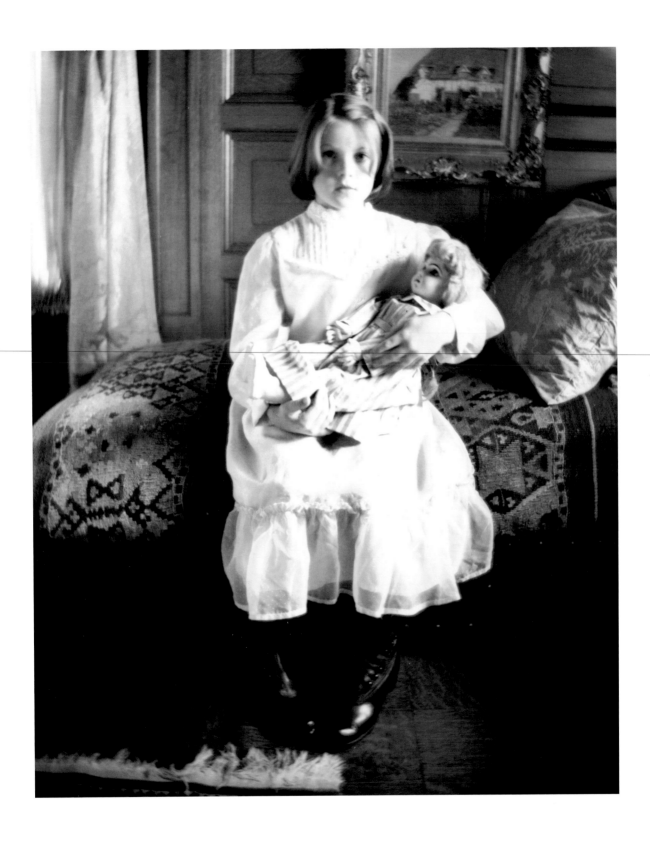

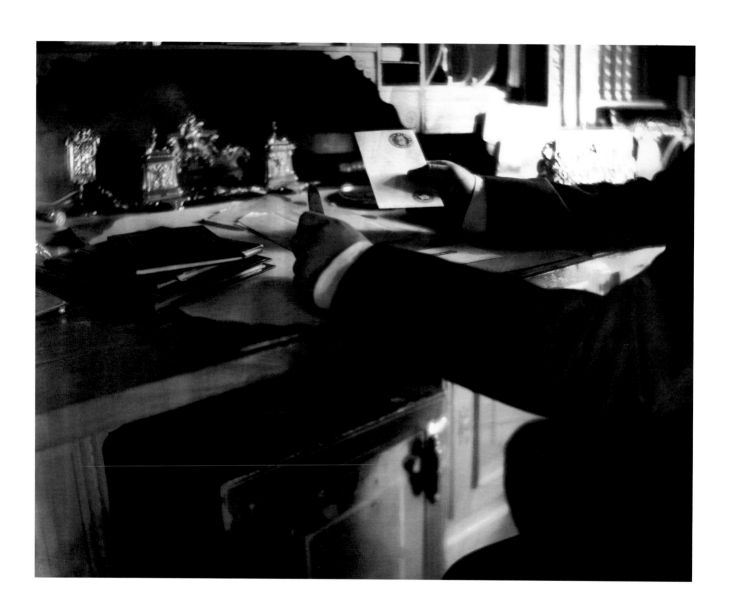

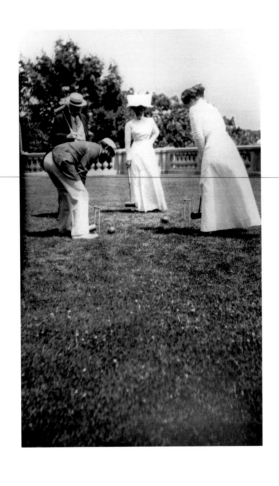

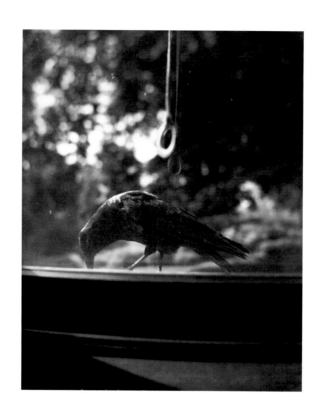

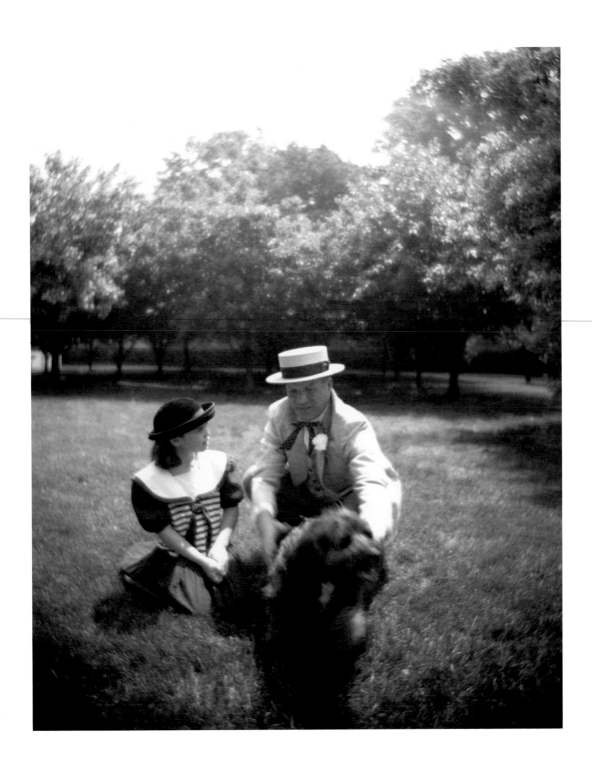

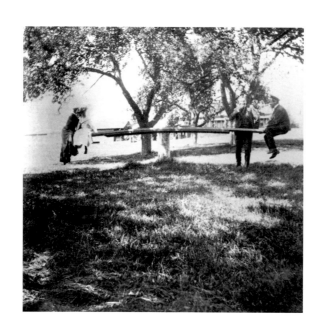

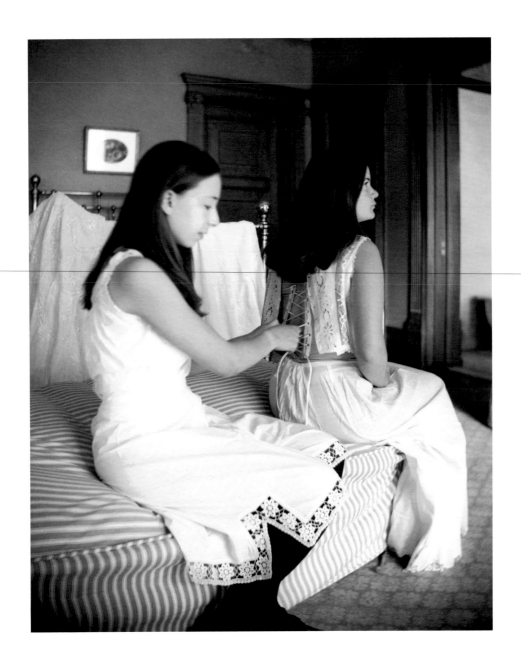

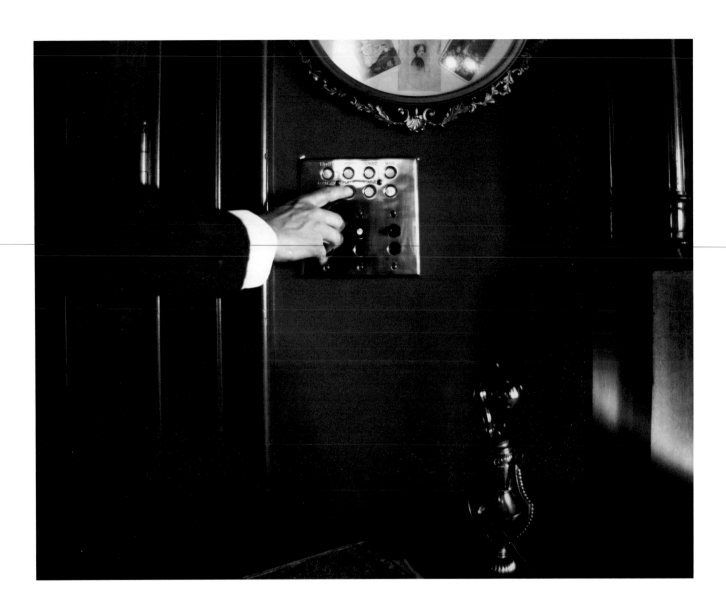

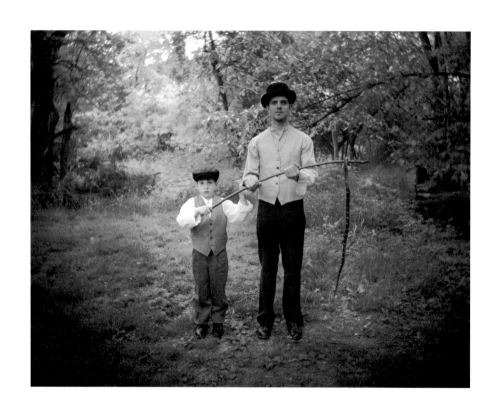

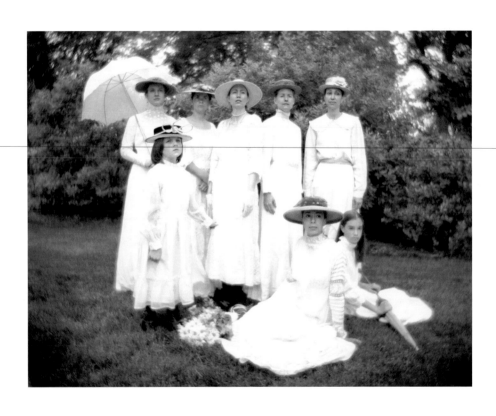

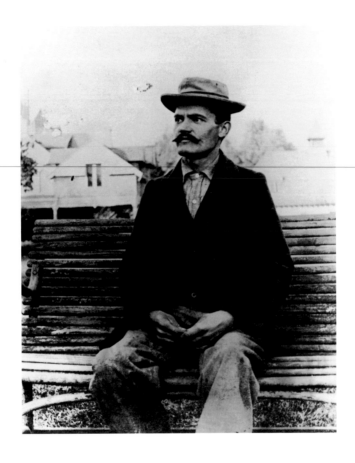

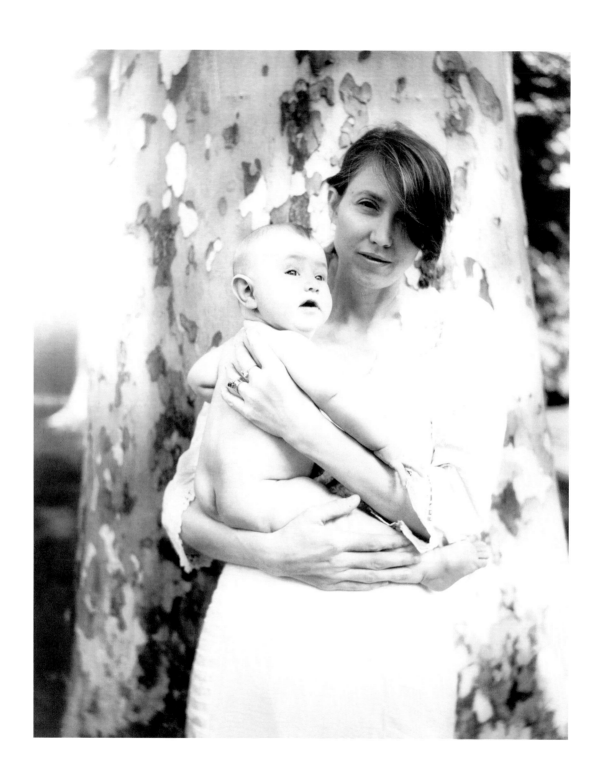

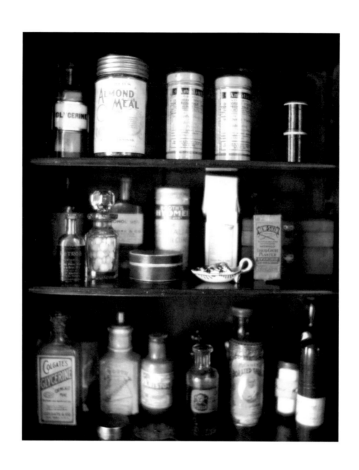

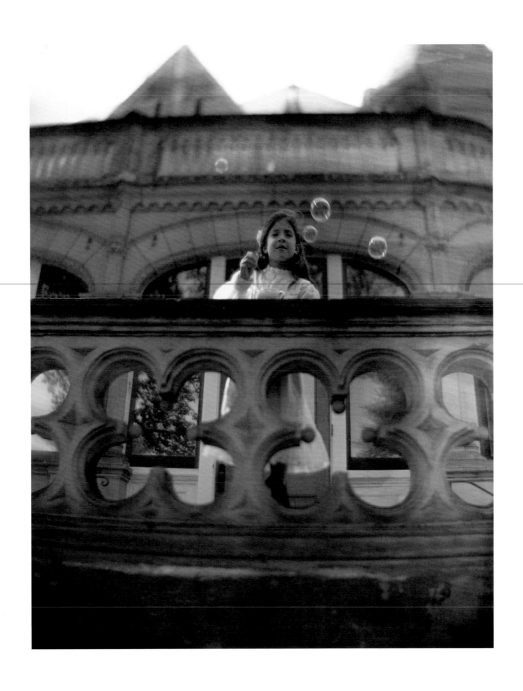

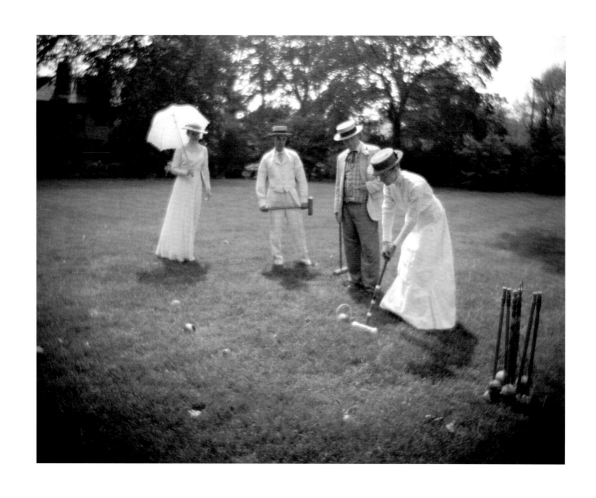

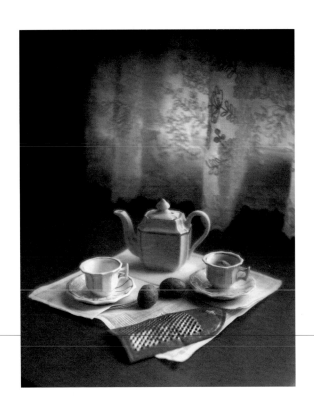

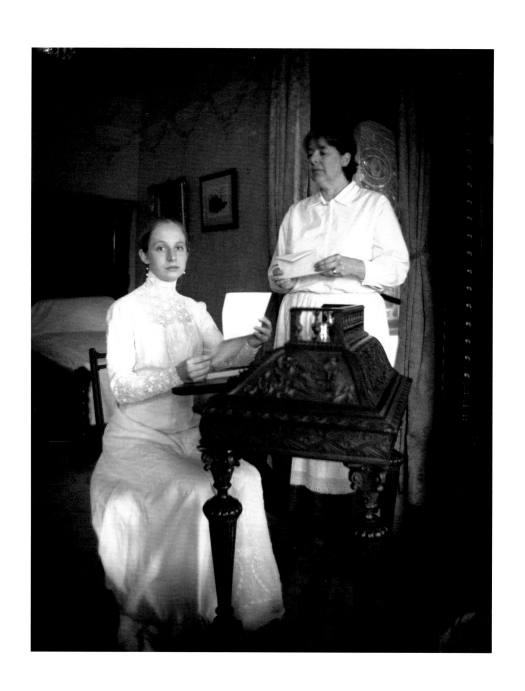

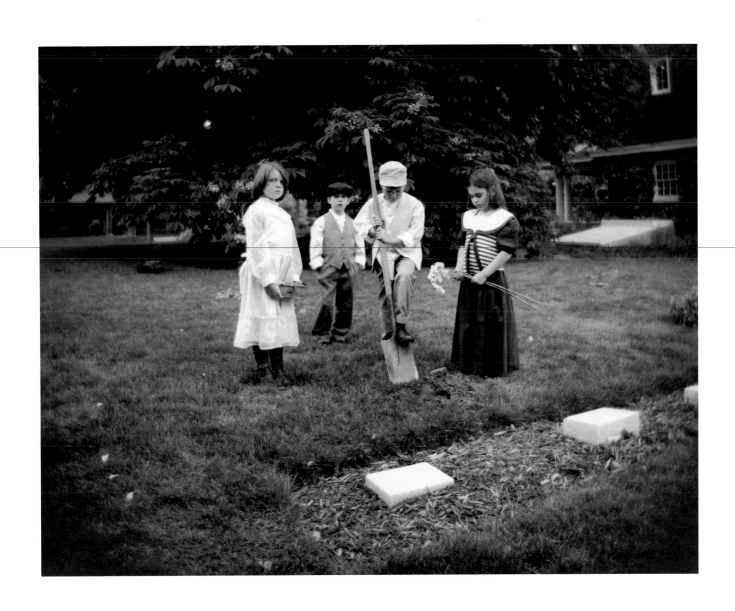

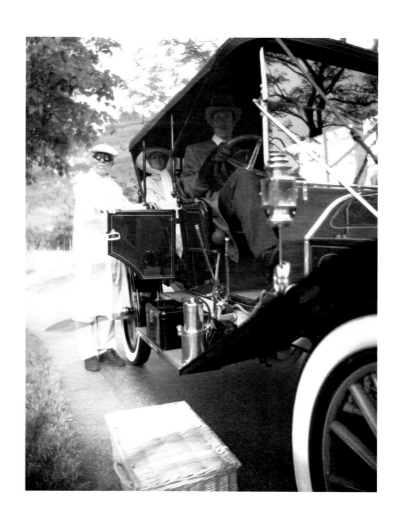

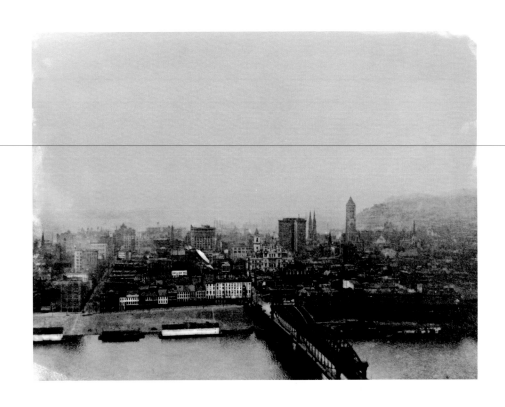

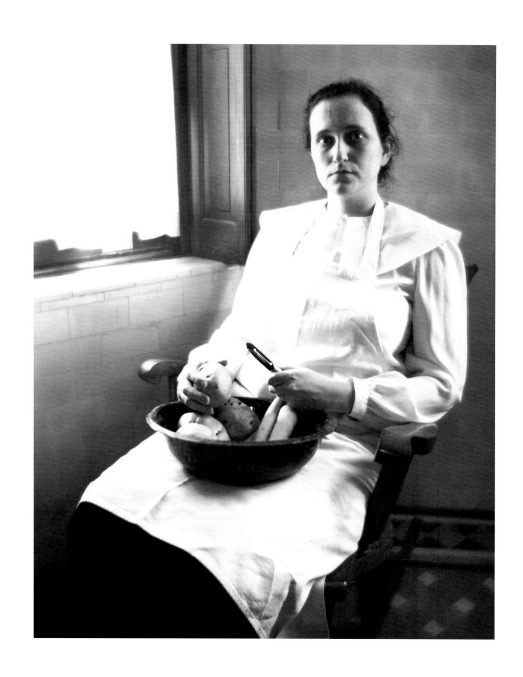

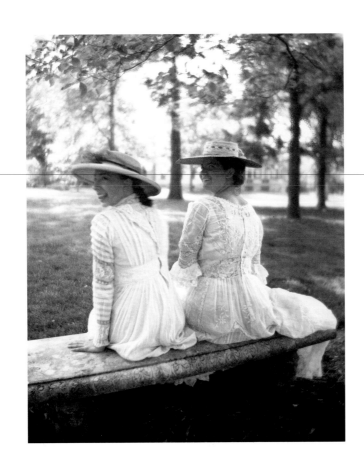

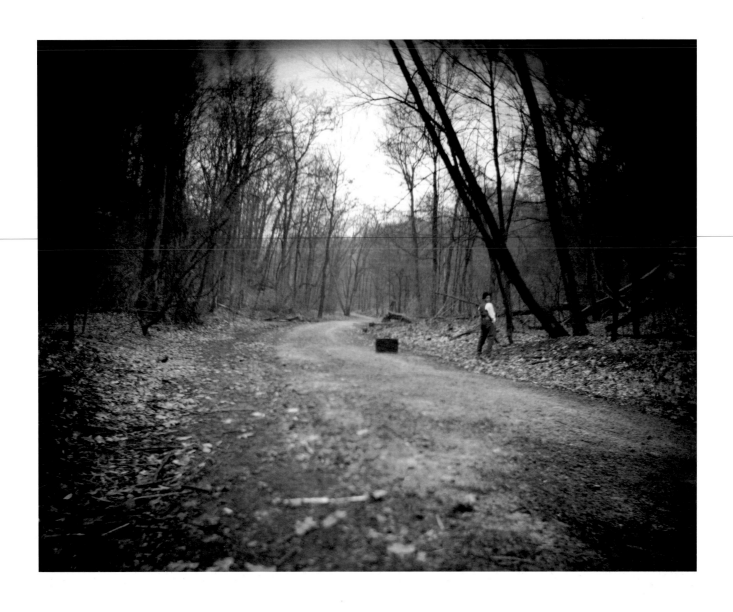

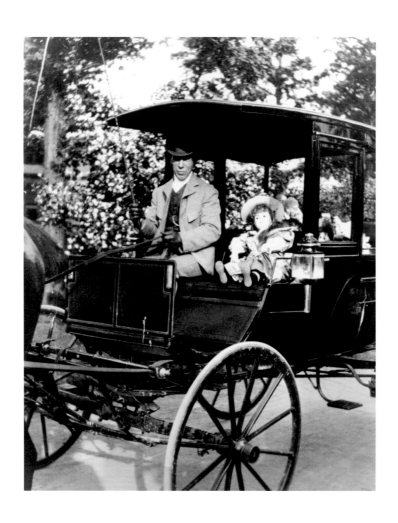

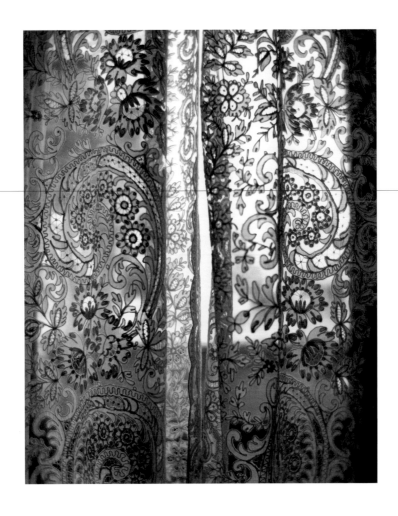

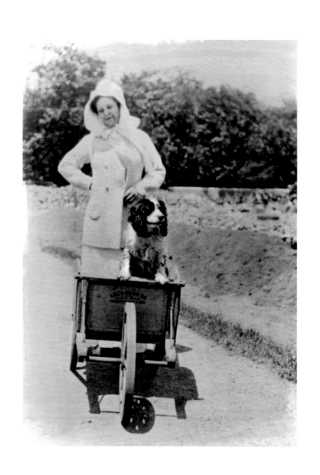

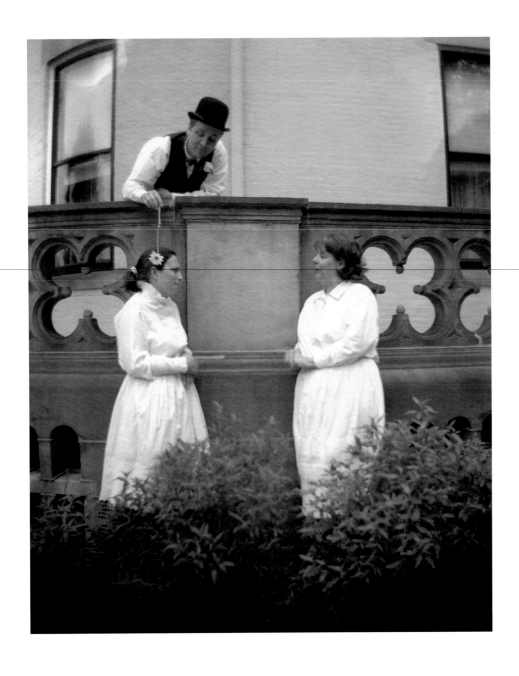

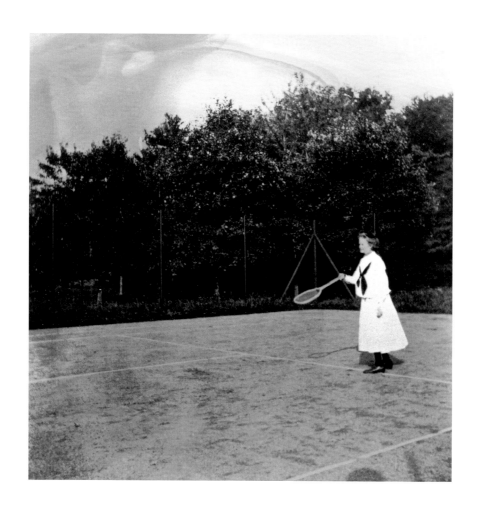

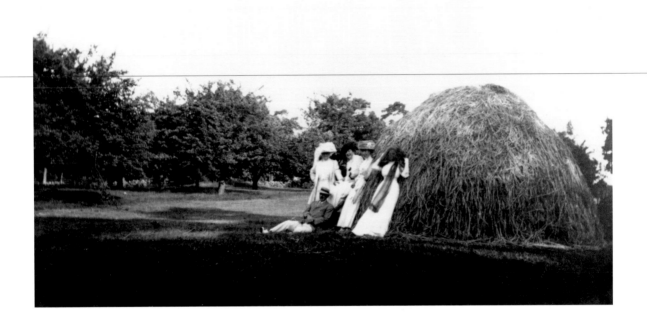

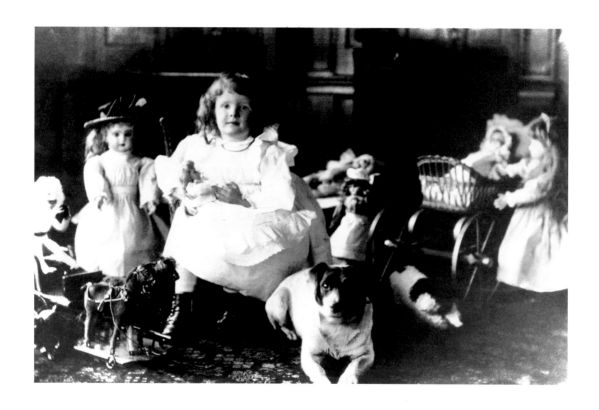

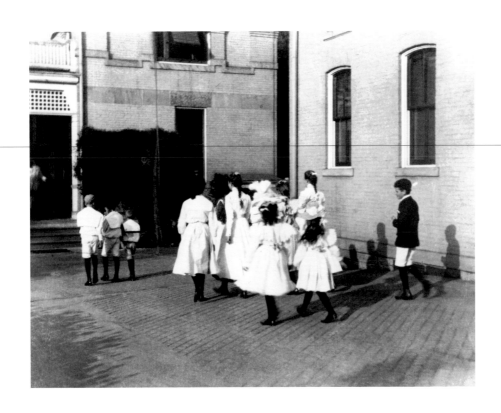

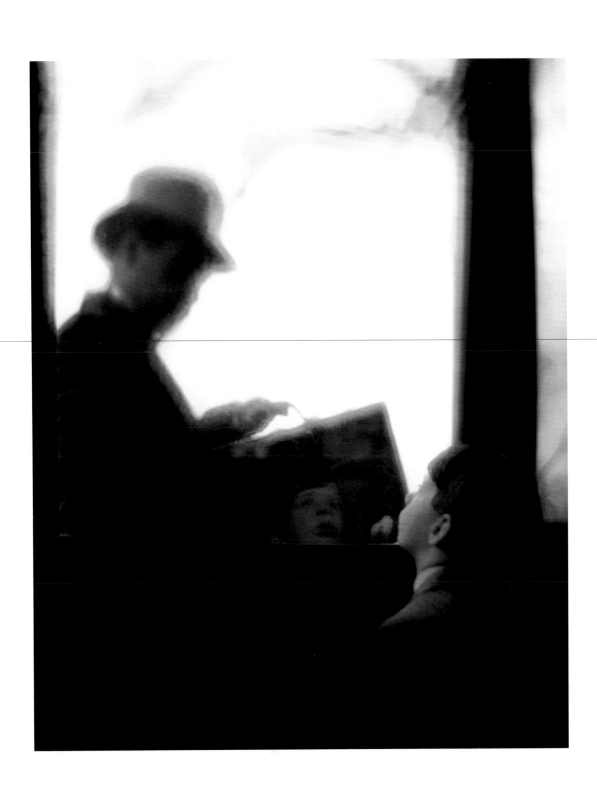

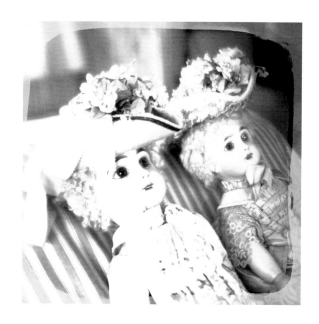

tendresse.

 — Madame, dit Louise, dans ma chambre, je dormirai tant que je voudrai ?

 — Sans doute.

 — Oh ! que cela va me sembler bon !... Madame, vous

Alors, je vais m'asseoir sur tous les meubles... (p. 88)

ne serez pas mécontente si je cours pieds nus sur le tapis ?

 — Pourquoi ne le feriez-vous pas ?

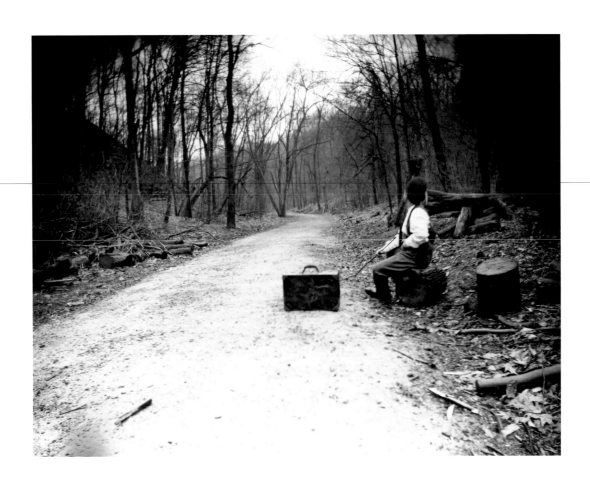

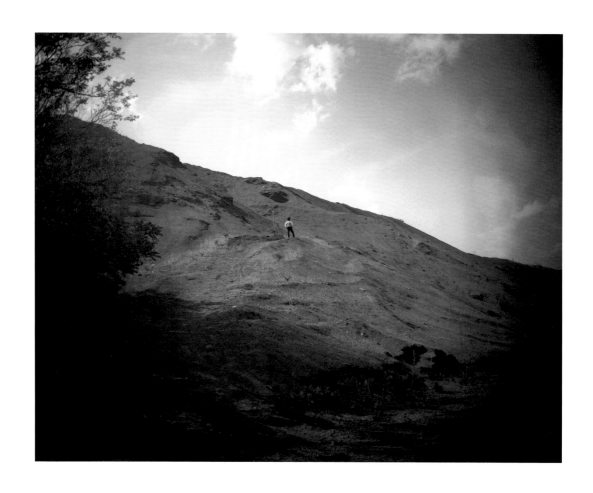

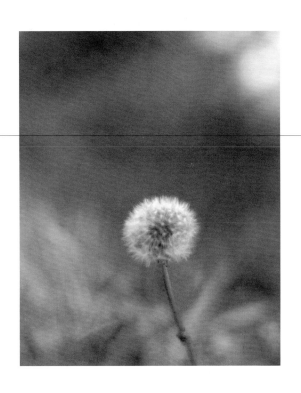

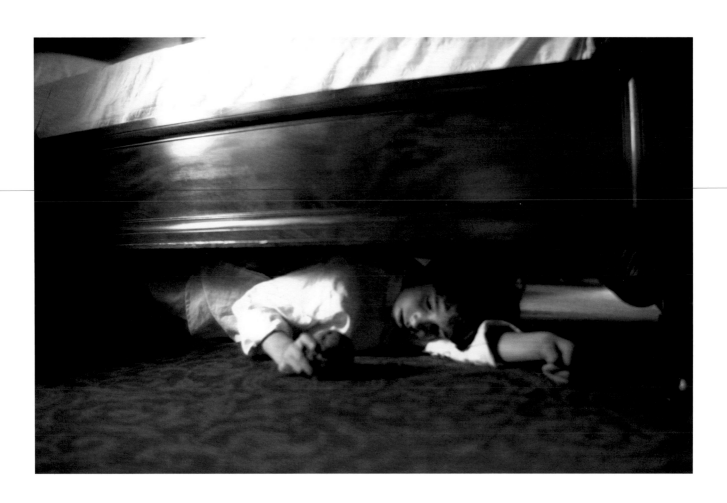

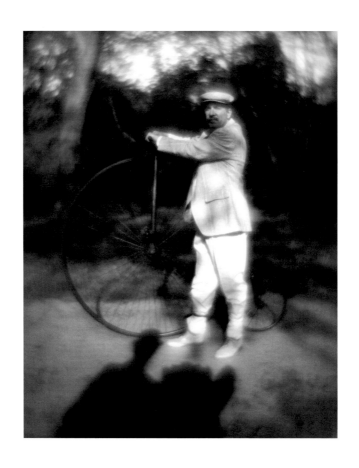

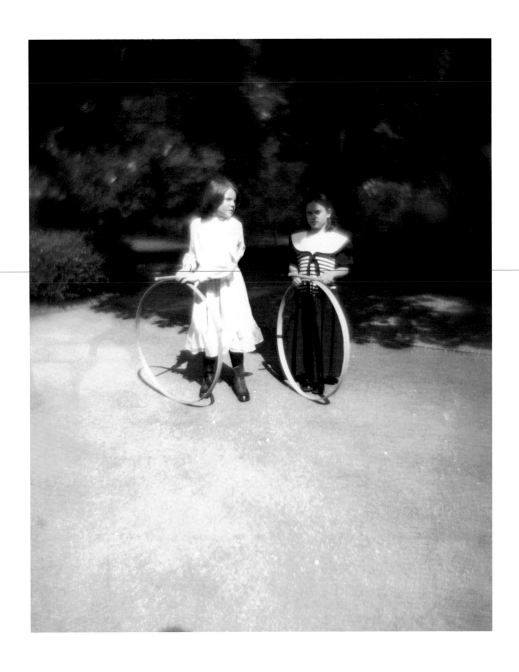

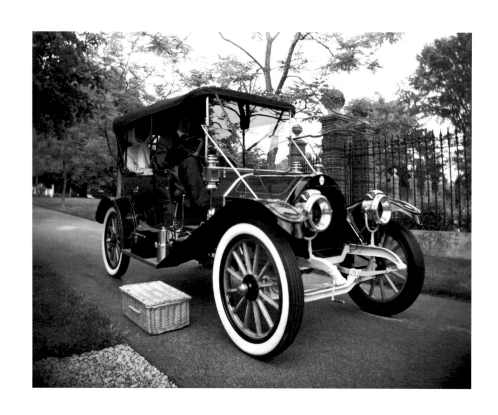

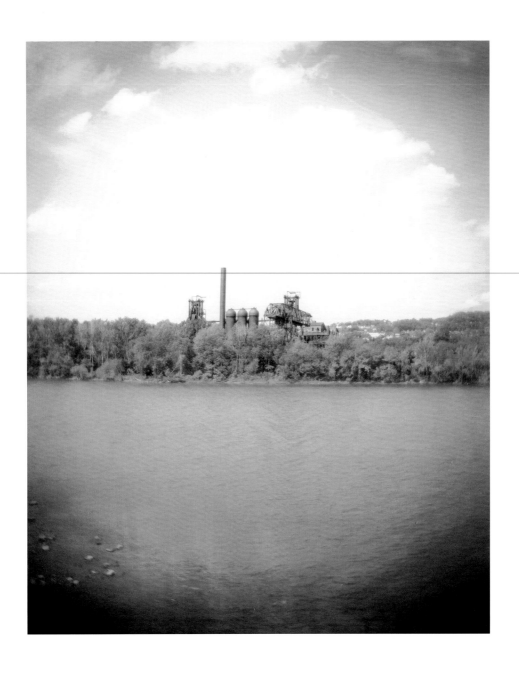

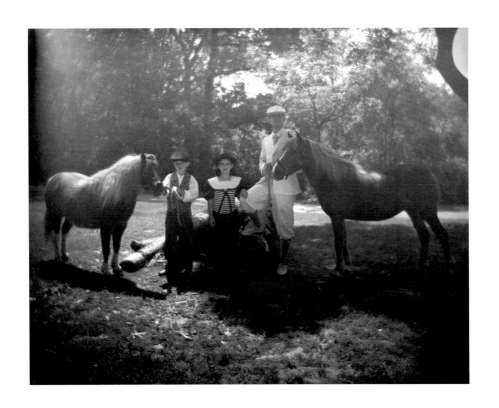

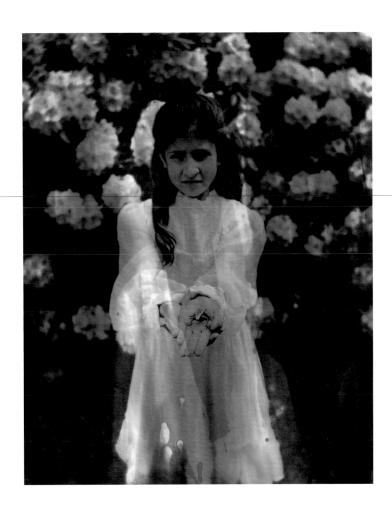

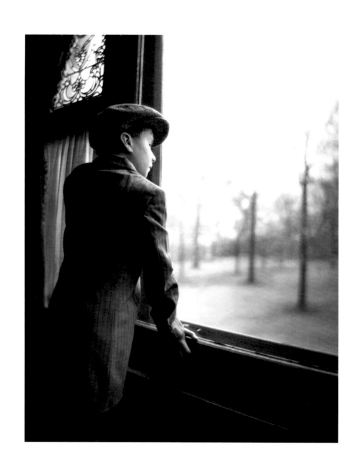

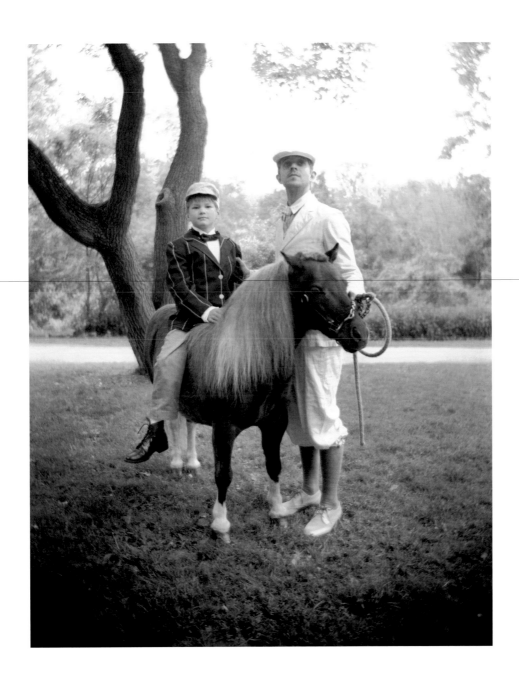

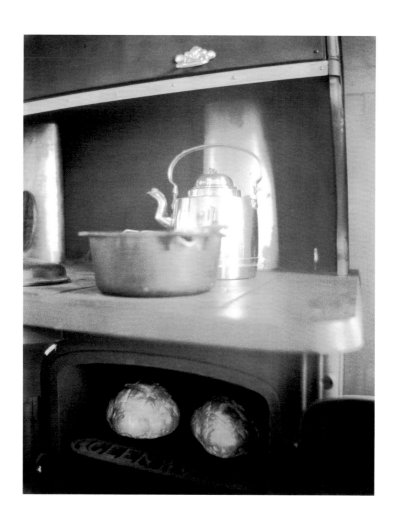

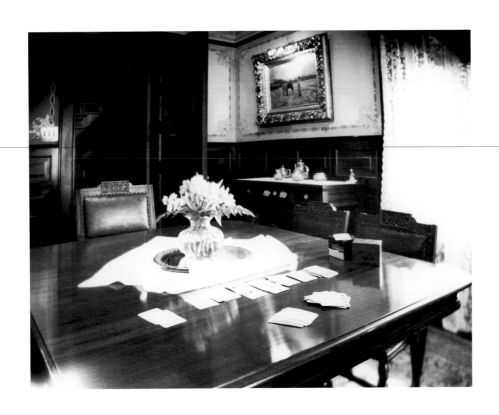

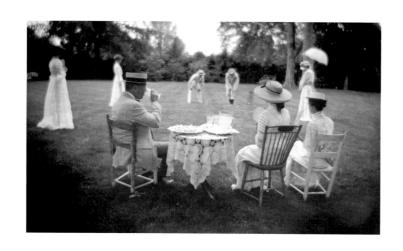

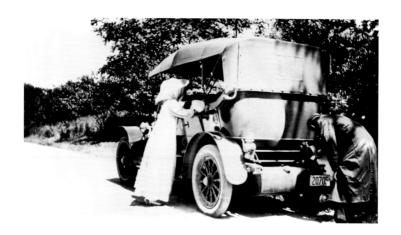

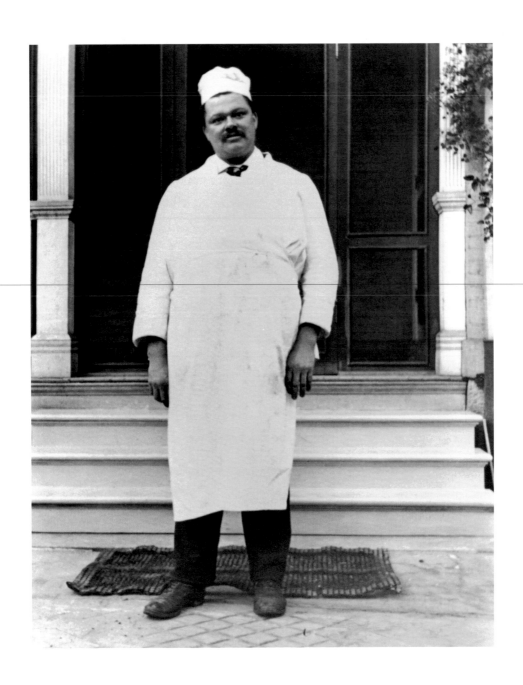

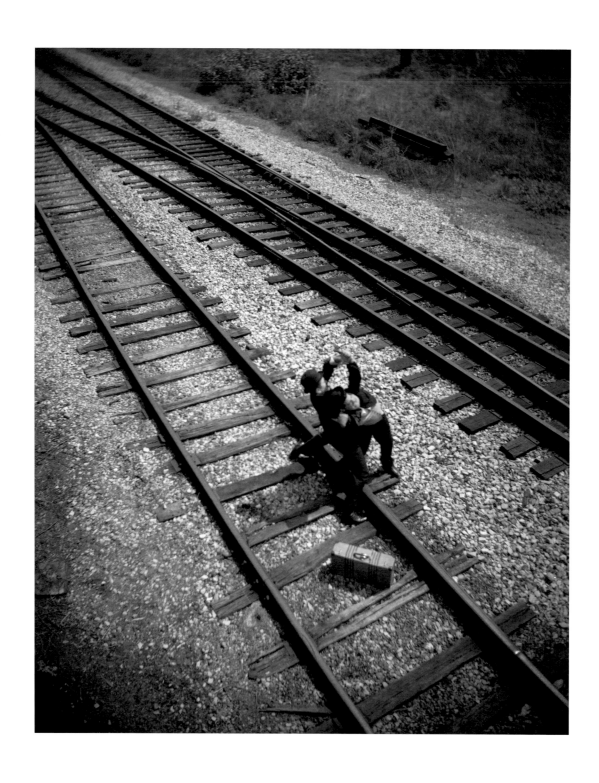

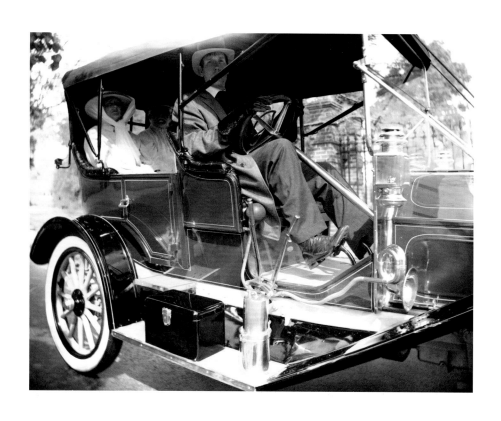

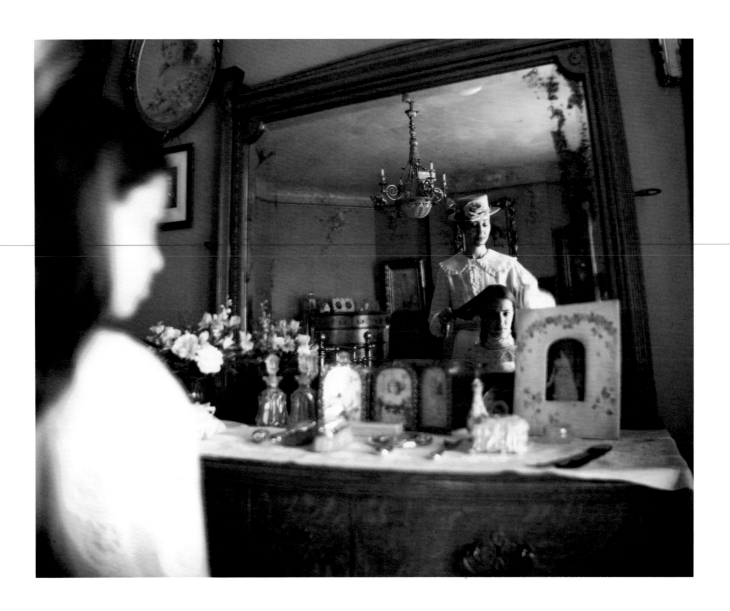

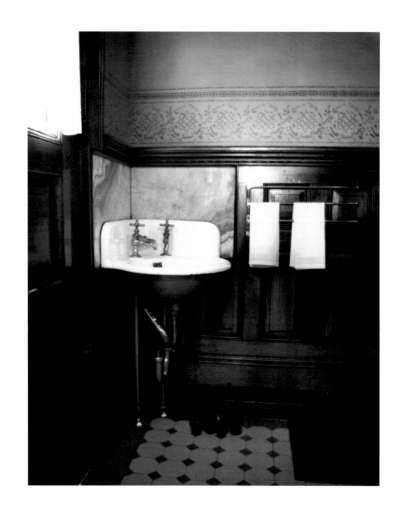

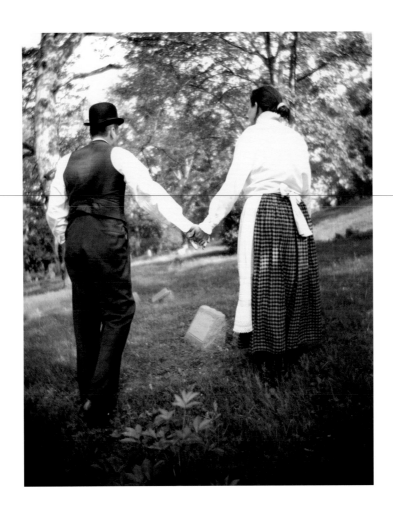

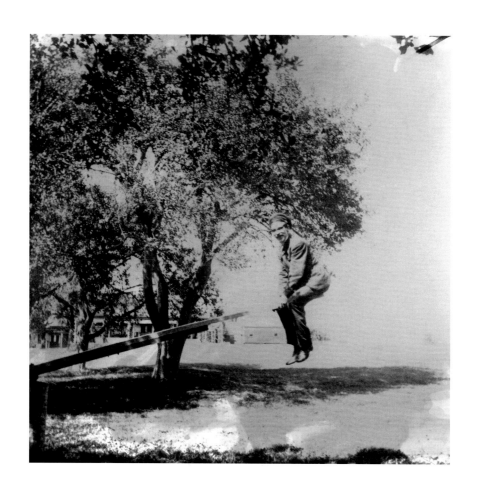

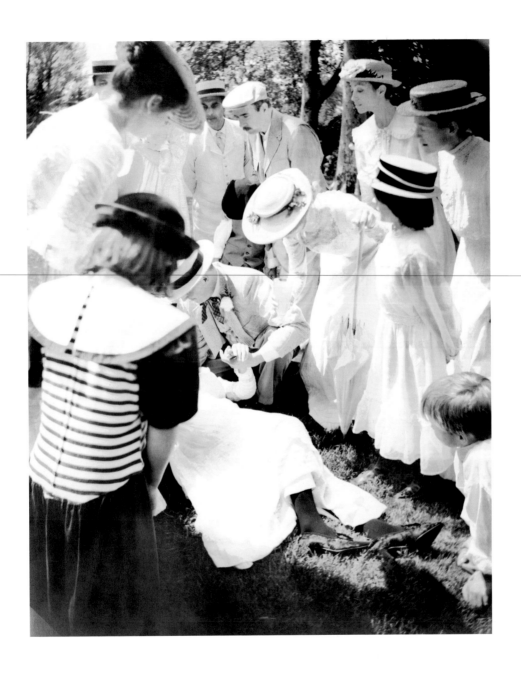

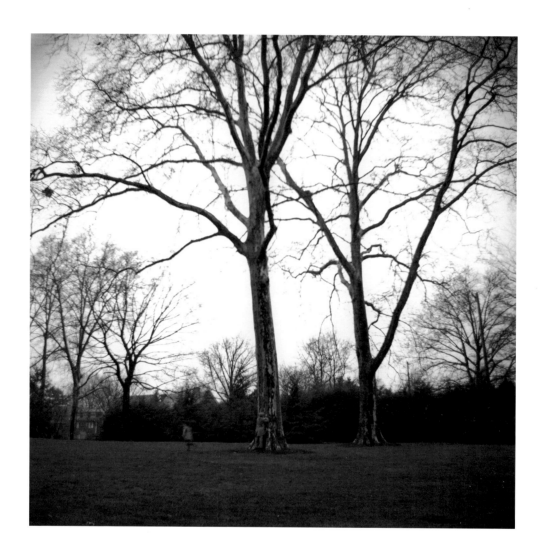

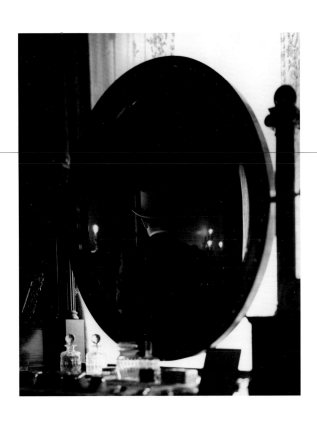

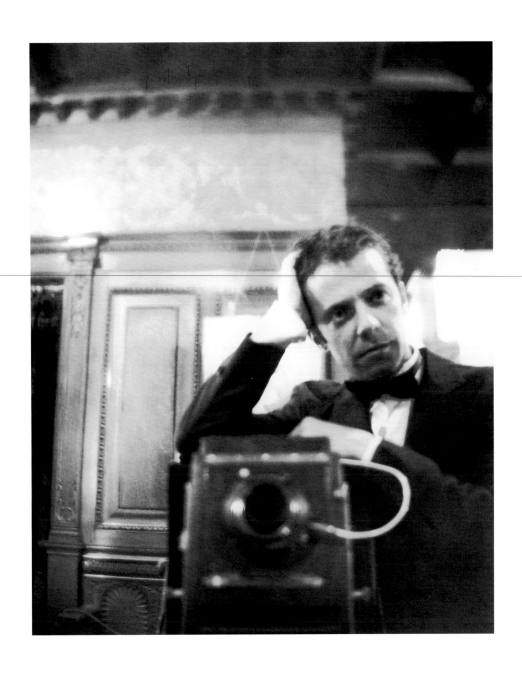

Titles

All dimensions are paper size; all prints are gelatin silver prints.

RAW MATERIALS, REPRESENTATIONS, REPRODUCTIONS, AND REPLICAS

by ANDY GRUNDBERG

"THE SUBJECT OF ART IS THE STUDY OF MECHANISMS responsible for conveying reality, and not the idea of reality itself." — Vik Muniz[1]

When Vik Muniz began to exhibit his work in New York in the late 1980s, it was clear that the world of art was in transition. The bracing momentum supplied by the major competing movements of the decade — Neo-Expressionism, which most often took the form of gestural painting and sculpture, and Postmodernism, which usually made use of photography — had ground slowly to a halt. To a large extent, this entropy came about because no convincing synthesis of the two seemed possible. Neo-Expressionist artists continued to believe that they were independent producers of original works of art, while the Postmodernists were adamant that such claims to originality were obviated by the omnipresence of reproductions, which created a simulated reality in which all experience was second hand. The result was near stalemate.

Fortunately, Muniz and several other young artists, among them Adam Fuss, Susan Derges, Thomas Ruff, Thomas Struth, and Mike and Doug Starn, arrived on the scene unburdened by the baggage of either camp. They quickly demonstrated that a wealth of possibilities existed in the gap between the poles of the Neo and the Post. Muniz and the Starns, exhibiting at Stux Gallery in Soho, shared a particularly invigorating hybrid approach, employing photographs in works that were sculptural in physical appearance and like paintings in terms of their hand-made qualities. In the Starns' case, this path in the '90s led to increasingly complex constructions in which translucent photographic films were suspended in steel cages and wooden boxes. For Muniz, however, the photograph became a replacement for sculpture — not merely as a flattened stand-in for three-dimensional objects but as a medium for pursuing his interest in the puzzles of perception.

Throughout the last ten years, Muniz's work has been a heady concoction (and conflation) of artistic media, but with the influence of the camera always having the first and last word. Speaking about his work in 1998, Muniz said that "Photography has allowed me to pack drawing, sculpture, painting, and theater into one tight bundle."[2] But Muniz is not interested in artistic media per se; he is intrigued by the ways in which representations, whether created by the hand or by the camera, are constantly reproduced and reconfigured in both cultural discourse and individual memory. As much as artistic media, then, he is interested in the effects of the popular media, such as news photographs, advertisements, and family snapshots.

In many respects, the work that first brought the artist to public recognition remains the best example of Muniz's interdisciplinary approach. Called "The Best of Life," and dating from 1988 to 1990, the series consists of "memory renderings" of well-known magazine photographs: Eddie Adams's Vietnam-era image of General Loan shooting a suspected Viet Cong soldier in the head, NASA's picture of the first astronauts' walk on the Moon. The pictures, hand drawn by Muniz from memory, have sufficient resemblance to evoke the originals. They look "good enough" to trigger our memories but in reality are only marginally faithful to the real photographs.

Of course, Muniz did not display his drawings of the photographs; that would have given them too great a claim to uniqueness. Rather, he made photographs of the drawings, using a halftone screen, causing them to revert to the condition of the images on which they were modeled. This circuit from photographic reproduction to drawing to reproducible photograph is also, in a perceptual sense, a short circuit, since it alerts us to the role our minds play in producing meaning from images.

"I want to make the worst possible illusion that will still fool the eye of the average person.... Illusions as bad as mine make people aware of the fallacies of visual information and the pleasure to be derived from such fallacies," Muniz has said about his work as a whole.[3] In the course of his career he has made work that is both humorous and child-like. For his drawings he has used wire, holes, thread, cotton, sugar, Bosco syrup, and dirt. He has fashioned send-ups of art-historical masterpieces by Bernini, Leonardo, Claude Lorraine, and Courbet, as well as classic photographs by Alfred Stieglitz, Frantisek Drtikol, and Harold Edgerton. He has taken vacation snapshots of Jamaican children, and used his hands to form the shape of animals in a series of x-ray images. In all cases the final result, the object that appears on the wall, takes the form of a photograph.

Unlike much Postmodernist art of the '80s, however, Muniz's work does not assert that the photograph's importance is a result of being a primary source of mass-media representations, and that mass-media representations are clandestine forces that shape our lives. Even granted its boundless reproducibility, the photograph in Muniz's eyes still carries with it the possibility of invention and intervention — an idea that his work capably demonstrates. In other words, Muniz's work argues that the camera lens does not determine meaning for us (or over-determine it, as some theorists believe) as much as it presents us with a field of potential meanings and potential responses.

This brings us to the project at hand, a body of work that is the fruit of the first-ever commissioning project undertaken by the Frick Art & Historical Center in Pittsburgh. At first glance, Muniz seems to have responded to the challenge by forsaking his customary method of traversing from original image to drawing to photograph. Here, for the most part, the photographs are "first hand" in the sense that they were taken by Muniz himself, albeit with antique equipment and antique techniques. The dissociative effects the artist usually gains by drawing are keyed in this case to another register, one located entirely within the syntax of the photographic medium. Yet the result yields the same sorts of cognitive dissonances and perceptual conundrums that his earlier work has led us to expect.

The photographs grow out of Muniz's response to the particularities and peculiarities of the Frick site, and especially to the way in which Henry Clay Frick's home, Clayton, preserves not only the story of Frick's life as he and his family self-consciously left it for posterity, but also more complex, less obvious, and darker narratives that in effect deconstruct the obvious one. In particular, Muniz was fascinated by the many photographs of the Frick family in the house, including a large number devoted to Martha, the Fricks' elder daughter, who died in childhood. Recognizing that there were any number of stories to be told based on the artifacts preserved in the house, Muniz set about creating his own, entirely imagined (and imaginary) narrative.

To an extent, the narrative told by Muniz's pseudo-historical photographs is purposefully open ended, so that viewers are invited to participate creatively by responding in ways that are largely personal. But the artist has set parameters for the pictures that direct our responses. For one, Muniz chose to place the camera lens at the level of a child's eye, making the images stand as proxies for an imagined (and invisible) youngster who is empowered for the first time to tell her own story. Second, through costumes, point of view, and photographic technique, he cast these pictures back some one hundred years — back, that is, to the era when Clayton was not a museum but the Frick family residence.

A hundred years ago photography was just becoming the cultural phenomenon that we know today. Casual photographs, best exemplified by the family snapshot, were made possible by George Eastman's invention of flexible film and of the Kodak camera, which came with the legendary promise, "You press the button; we do the rest." Taking photographs became an avocation instead of a craft. In addition, the development of halftone reproduction made possible the widespread diffusion of photographs in magazines and newspapers. Both developments depended on industrial processes developed in the nineteenth century. Similar processes enabled Henry Clay Frick, among others, to accumulate great wealth during America's "Gilded Age."

As Muniz has noted, Clayton as we know it today is a reconstruction, and decisions about how to place the furnishings and family memorabilia are likely based on photographs taken in and around the home at the time that the Fricks lived there.[4] Photographing in the house, for Muniz, was like taking a picture of a pre-existing photograph. To acknowledge and extend this idea, Muniz has replicated some of the photographs now displayed in the home and mixed them with his own, wholly fabricated images. This mélange of historical memory and imagination, of artifact and simulation, suggests that what we believe about the past (and often claim to know) is a construction based less on empirical knowledge

than on its own narrative coherence. As Muniz puts it, "history is dynamic,"[5] so more than one narrative is always possible.

If the subject of art is the study of the mechanisms responsible for conveying reality, as Muniz has asserted,[6] then the subject of these pictures is the study of the mechanisms through which photography encodes the past. Rather than constituting a fixed history, the past contained in these representations is an unstable, uncertifiable terrain. By sacrificing the illusion of certainty, however, we gain the possibility of more than one reading of what the past might have been. And, as the artist has done before us, we can actively insert ourselves into these readings.

Some of the "pastness" of the prints derives from their subjects, but to a large degree it is a matter of the photographic syntax itself. By choosing to work with a large-format camera, Muniz has reproduced the look of 19th-century photographs before the coming of the snapshot — a look that photographers with ambitions to be artists carried into the twentieth century. The sense of stillness and repose we feel can be attributed to this "pictorial" manner. In addition, the prints were produced to appear as if they date from the adolescence of photography's technological development.[7] This allows us to consider them historical, if only for the moment it takes to discover some anomaly or anachronism.

On close inspection these pictures give themselves away. There is, as already mentioned, the matter of point of view: few children ever stood behind a view camera, much less brought it down to their level. Then there are the views themselves: close details of cabinets and countertops, reflections in mirrors and scenes framed by windows, film-still like encounters that include the figure of the photographer. These clues from the reflexive repertory of modern art and photography, combined with the presence of genuine (albeit rephotographed) Frick family pictures, are enough to signal to us that we are in the presence of a replica of historical experience, not (again in Muniz's words) "the idea of reality itself."

The notion of the replica is central to Muniz's artistic project, which is why photography plays such a central role in his artwork. The replica, thought of as a nearly perfect but often miniaturized model of a thing, is a nearly perfect metaphor for what photographs are. But as replicas photographs are inherently faulty: they lack a third dimension, they describe only one viewpoint, they exaggerate or nullify normal perspective. So we always recognize them as

substitutions for real things, even as we depend on them to tell us what we need to know about the world, about both history and current events.

In the 1980s, photographs were described as cultural representations most often in terms of reproductions. Reproductions are also models and replacements for originals, but they exist in theoretically endless multiples. Famously, Walter Benjamin, a German critic writing in the 1930s, forecast an "age of mechanical reproduction" in which photography and film would revolutionize art by dispensing with the very idea of an original. Fifty years later his thinking underlies much of contemporary art. Artists "reproduced" existing photographs and called them their own in the name of demonstrating the postmodern condition. The chain of photographic reproduction circled back on itself, like a snake biting its tail.

Both reproductions and replicas could be categorized as counterfeits of experience, but replicas have the virtue of having a claim to being originals themselves. Their originality rests with their imperfections, with the deviations small and large from what it is they represent. Reproductions are also representations, of course, and therefore similarly inadequate before the original, but they are indistinguishable (at least in theory) from each other. Replicas are unique, a matter of fabrication and craft. Muniz, by focusing this study of photography and history on the replica, requires viewers to be alert to the differences that distinguish replicas from their original sources and, at the same time, to recognize how much originality his replicas possess.

Paradoxically, but appropriately, the first art of the twenty-first century looks back past 20th-century Postmodernism and Modernism all the way to the nineteenth century. For us, on the cusp of a new technological revolution — one that is replacing mechanical reproduction with electronic simulation, among other things — the nineteenth century holds a special allure and special lessons. When we cast ourselves imaginatively into the gilded atmosphere of Clayton, fleshing out the closeted narratives for which Vik Muniz has provided the skeleton, we may discover that the child is the father to the man.[8] Photography, one of the major inventions of the progressive and transformative nineteenth century, even now provides us with evidence of our endless gullibility.

1 Vik Muniz, interview with Charles Ashley Stainback, in *Seeing is Believing* (Arena Editions, 1998), p. 17.

2 Ibid., p. 41.

3 Ibid., p. 16.

4 See interview with Linda Benedict-Jones: "Clayton has a little bit of that because the organization and display of objects in the rooms is probably based on photographic sources. So when you take a picture, you are actually taking a photograph of a photograph."

5 Muniz, telephone interview with the author, June 9, 2000.

6 Muniz, interview with Charles Ashley Stainback, op. cit.

7 The prints were made using the standard silver-gelatin process, which has been in use since the 1890s, and then artificially aged by the artist to resemble photographs that are a century old.

8 What I mean here, in terms of representation, is that the nineteenth century may hold valuable lessons for us even as we in the twenty-first witness a technological transformation of a different sort. I do not mean to be gender biased, especially since the photography artifacts at Clayton quoted by Muniz suggest that in Henry Frick's case, the daughter is the spirit of the man.

INTERVIEW WITH VIK MUNIZ, FEBRUARY, 2000, PITTSBURGH

by LINDA BENEDICT-JONES

LBJ: THE FRICK HAS ASKED YOU TO WRAP YOUR CREATIVITY around something on their site, and it seems that you are most interested in Clayton, Henry Clay Frick's historic home. The Frick is known for 19th-century work so the mere fact that they are doing a project with a 21st-century artist is really quite incredible.

This is the first artist in residence program at the Frick Art & Historical Center. It was inspired by the program at the Isabella Stewart Gardner Museum in Boston.

VM: It's interesting that you mention I'm a 21st-century artist. I never really felt like a 20th-century artist to begin with. Being able to work at the headquarters of the nineteenth century is a pleasure for me. If a person is required to make art at the end of the twentieth century, perhaps it is necessary to take two steps back in order to continue the project of art in general. I've always been fond of 19th-century art. In the nineteenth century photography was invented; in the nineteenth century machines and the whole spectrum of social life, the reconfiguration of the family came into being. Even though I was born in the twentieth century, everything that has ruled and structured my life and my knowledge of society has been based upon ideas that were primarily developed during the previous century.

With photographs you can see history through your own eyes and you can make your own judgments and interpretations. I decided to work at Clayton instead of with works from The Frick Art Museum because Clayton has something a little bit more personal and a little bit more particular to offer. When you walk in, you see children's shoes at the entrance. You see little things here and there that help you have an understanding of the history at that time. The way we learn history is always through very interpreted sources.

Clayton looks like a photograph, to begin with. I've always been drawn to places that are set up or organized in a way to provide visual references. Dioramas in museums, or wax museums, become very confusing when photographed, because they're things that were made to be seen in person.

LBJ: You say Clayton looks like a photograph. Can you explain that a bit more?

VM: The impression you have when you go into Clayton is that people are still living there. It's like they have left for fifteen minutes just to allow a tour to go by. There's something about the placement of the objects in the rooms that's clearly organized, developed, and maintained due to photographic documentation of the place.

You know, I was in Arles a few years ago and I saw that somebody had bought the café where van Gogh had once been and they had painted the entire café with the colors that van Gogh painted with. It was pretty weird and funny at the same time. I remember they tried to make the place look like the painting. Clayton has a little bit of that because the organization and display of objects in the rooms is probably based on photographic sources. So when you take a picture, you are actually taking a photograph of a photograph. In my work I have always favored this layered type of image organization, and I'm drawn to images like that. When I look at Clayton, I see many, many layers of representation worked one upon another. When an image is already very complex to begin with, adding to it makes it harder to read and a little bit slower to interpret. So I like images like that — slow images. I'm a slow visual artist. So I think like an artist of the nineteenth century.

LBJ: Process is clearly an important element in your work. At least that's how I perceive it.

VM: Yes. Process enters my work as a form of narrative. When people look at one of my pictures, I don't want them to actually see something represented. I prefer for them to see how something gets to represent something else.

Sometimes it starts with a subject and then I search to find the most suitable process to make that subject and then, sometimes, I just go backwards from there. Other times, I find a different process for making an image and I go looking for subjects, but either choice is based on the relationship between one another. Starting with the subject or ending up with a subject is pretty irrelevant.

LBJ: You have been thinking a lot about your choice of lenses, your choice of film, the time of day, how you are going to age these prints, how you are going to work with them. As a result, you have worked out a lot of that before even making your first exposure. I find this intriguing because I think many photographers work the other way around.

VM: You know what, it saves film.

LBJ: Yes … (laughing).

VM: I edit the work a lot before I do it. It's economical. Even if I work outside, I have a studio photographer's mind. I know that every single choice I make will change the meaning of the image. It becomes very important to orchestrate these choices so that they contribute to a very solid, closed, structural concept. Once I define the concept, I go about trying to find the best way to do it. In many cases, the best way has nothing to do with good quality of image or good photography of any kind.

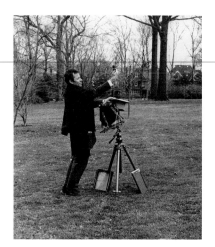

For the work at Clayton, I decided to use period equipment, you know, 19th-century optics and 19th-century hardware. And I'm printing in the most primitive way possible, now they call it "alternative," to create the sense of a document that may point out another time period.

We're very well trained as far as identifying traces of the development of media in photographs. We know what an early 20th-century movie looks like because people walk funny in them, and we think people walked like that in the early part of the century. We always think that people in Vietnam were kind of yellowish-green because of the way Kodak made the film at that time.

That's one of the ways to convey messages through the work, by choosing a language — a technological language to speak through. It entirely changes the meaning of a photograph: the way you shoot, the way you decide the angle of approach, from where you want to see it, if you want to see it from the eyes of a 20th-century person or a 19th-century person. You can coach yourself like an actor and place yourself into that time and try to take pictures like that person.

A little bit is fear, too. Starting a project is always hard. You have to be over a cliff to do it.

LBJ: Your approach is intriguing. I see how it does reflect that of a 19th-century studio photographer.

VM: I'm more interested in how pictures get conveyed. What's the language of the thing I'm photographing and how do I learn about it? How does a photograph bring to mind somebody, and how can I photograph them? I'm interested in the linguistics of an image. I want to see where the verb is, and the subject. Is there an article? What's the object? It's like when you go to have your picture taken and the photographer says, "smile." You know, you are not really smiling. You are just answering to a command of some sort.

I try to break images down like that and analyze them. So, in a way, it's a very analytical approach, but I try to make it seamless. I don't want the images to look conceptual because the moment it looks like I'm trying to come up with some idea or some intellectual scheme, it will scare people away and they'll become defensive, you know?

LBJ: They'll become alienated?

VM: Yes. I want the pictures to be beautiful and I want them to be easy to look at and I want them to have a residual effect. I also want them to be intelligent. I want to keep that edge to them, but I don't want people to know that.

LBJ: I'd like to go back to Clayton for a minute. You seem to be interested in this notion of presence, but you are also interested in concepts that are related to children. I've seen you photographing children in the kitchen, for example. How are you choosing what to really focus on?

VM: I think that it's probably based on the little experience I have with theater and sculpture. There's a great difference between gesture and posture, and there are clearly elements of Clayton that are gestural.

LBJ: Such as …

VM: I think somehow when you walk in, there are places like the bathrooms or the kitchen that seem to leave more marks of existence. My favorite room is the library, where everybody seemed to spend a lot of time together.

When the house was occupied by the Fricks, it was a kind of museum even then, because a lot of it worked at the level of display and appearance. Those are the rooms that I really don't care much about because they seem less real than the other parts of the house. The other parts look more like people lived there, not just, you know, "Henry Clay Frick and His Family."

LBJ: Right. Appearance was tremendously important to the upper classes during the Victorian era.

VM: The Fricks were just people, and that's the human perspective that I'm trying to emphasize through these pictures. History has been written about the house and the people who lived in it. I wonder if there are other kinds of histories that could be written at different levels about the use, say, of a railing or the way a doorknob looks polished because it was handled so often. Things like that.

LBJ: Details?

VM: Yes, but history can be seen and can be told in many different ways. I've taken the tour of Clayton with different tour guides and every single one tells a different story. Although they all have the same text, they emphasize different parts — just in the way they raise their voices. Their enthusiasm is different in each room of the house.

History itself works in many layers, and I would like to approach not only the way the spaces of Clayton lend themselves to many interpretations, but also why the people who work during these tours are interested in different things. The interaction between the employees and the space is part of the preservation and maintenance of this history, and it's also the way it evolves.

LBJ: Absolutely.

VM: History changes, because it's like the game of telephone. Once it enters the realm of human interpretation — and especially when you pass things verbally from one person to another — inadvertently you interpret it and you change it.

LBJ: I don't think that anyone has ever gone to Clayton with the purpose of interpreting the house visually before. Your kind of interpretation is rich, in part, because it's of a different kind.

VM: Well, it's rich and it isn't. An image is not like a statement or a command, unless it comes with some text attached to it. I thought that by photographing Clayton I could convey a sense of the complexity about the way in which many stories have been told and have favored one person or another, or have taken sides trying to portray somebody as a one-dimensional character in a play when, in fact, people are not that simple.

I knew the story of Henry Clay Frick just a little through the story of labor in the nineteenth century. That's all I knew about him before I visited Clayton. When you walk into the house, you have access to a different set of factors that you can go by when thinking of his personality. There is an incredible presence of children in the house, too. You feel the sense of a family, of a man who was deeply devoted to his children. That affects me in a sense because I've worked with children many times. And I'm a father myself. Maybe that's why I asked myself this question: Would I be as affected by this man's dedication to his children if I wasn't a father, especially a father who doesn't live with his son?

LBJ: You've talked about illusion and how it informs your work, but that making illusions is not what you want to achieve. Would you explain that idea a little more and how it may or may not apply to what you are doing at the Frick?

VM: I'm still a maker of illusions, you know. I draw. I'm an artist. I don't feel a need to work against that because I think it's the most natural way for me to express myself. I am making interpretations of Clayton or trying to devise interpretations for things that may have multiple meanings. It never changes.

LBJ: Narrative appears to be a key element in your work. Are you creating a new story for us about Clayton?

VM: I'm not creating a new story. I'm just trying to feel what my story looks like. I'm pointing out the complexity of interpretation that a place like Clayton can offer. I realized that there are no photographic documents from the nineteenth century or even in the early twentieth century that share a child's point of view. Cameras were mainly displayed in a perpendicular angle to the image. The lenses were about five feet above the ground, which would have been about eye-level to a grown man.

I decided to document the place using a much lower perspective, one similar to that of a girl of four or four and a half. I even tried to look at the places, the objects, and everything around the house like a child would. I don't know what many of the objects are for, but I think that maybe even a girl of four wouldn't either. I'm very drawn to these particular objects, and I want to focus on them.

LBJ: It seems that working with children keeps the idea of innocence alive for you. Is that true?

VM: I'm going to Brazil next year to do pictures of children who work in coal mines, like Lewis Hine all over again. I like to observe children looking at things, because they are pretty clear about the way they look at them. It's a very primitive state of perception. You learn a lot from looking at the way they perceive the world, and it works a little bit in the way that I would like photographs to be. I would like everybody to have that.

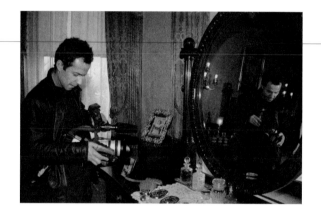

LBJ: I understand you did a one-month residency working with street children in Brazil for Projecto Axé. Weren't you more or less helping kids to express their wants and desires in visual terms, something that must have been quite a unique experience for them?

VM: Yes.

LBJ: And here you are...

VM: ... using childhood as the subject.

LBJ: In Pittsburgh you'll be meeting with some elementary students from schools near the Frick. What are you going to talk to them about?

VM: Children, until a very advanced age, cannot differentiate between fact and fiction. They see the news the same way as they see a soap opera. They are not told that there are subtleties and that there are differences between reality and TV. It's all a big soap and that soap has to be sorted out later on.

As images become more eloquent than words — because they are much more powerful than words — words seem to be just an excuse to have a very powerful image. As you are reading something underneath an image, you are being totally overtaken by what you are looking at without knowing it. So, in learning how to see images that you see on television, through computer media, or even in a magazine, it's essential for you to speak the same language as the people who make them. This is very important for kids to learn in school. Kids know about blacks and whites in photographs, you know, once they are ten or eleven, but some people spend their entire lives not seeing the variety of grays that a picture can have.

LBJ: *Seeing is Believing*, as your book title states. You know, even in college-level classes on the history of photography it's necessary to spend a significant amount of time on the subtleties of "reading" an image.

Vik, I want to ask you something about Brazil. We all think of you as a New York artist, but...

VM: Really?

LBJ: Well, yes. I mean, you live in New York and so we've come to know about you by reading about you in *The New York Times* and the show that you did for the International Center of Photography and your other shows in New York, and yet you are Brazilian. There are so many wonderfully creative people from your country: your great novelist, Jorge Amado, and the education theorist, Paulo Freire, and so many celebrated musicians like Antonio Carlos Jobim and, my favorites, Vinicius de Moraes, Baden Powell, and Maria Bethânia. When I listen to you speak, you speak with a certain fluidity that is reminiscent of the flow and the fluidity that I feel about your fellow countrymen. You have mentioned in other interviews different artists who have inspired you, but I've never heard you make any reference to Brazil.

VM: My Brazilian education is more of an education of the senses, not names and biographical and historical elements — not that they are not there — it's just that I go beyond their names. It all becomes kind of a sensual thing.

I am a Brazilian person rather than a Brazilian artist. I grew up in the '70s in Brazil and that has had a profound impact on what I do, and it has had a profound impact on the art that I really like. Music that was done during the '70s was done under a climate of extreme repression by the government. Artists resorted to metaphors because, although they had things to say, they couldn't just say them. You became aware that there were many ways to say the same thing — that there are many techniques and mechanisms and that these contraptions are inside every single image, every single statement, every single song.

There are many devices that I use, like Cãetano Veloso and the Tropicalia People. They are musicians who were singing love songs about flowers and beautiful things — like Sunday in the park. But they were actually talking about other things. If you were young and intellectual and had some access to the information of the times, you could read through all their codes, and you could realize that there were very powerful messages within those love songs.

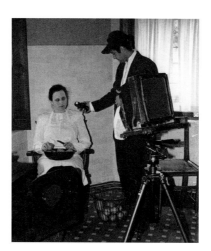

Instead of screaming some kind of truth, somebody comes and just sings a beautiful song, but that song tells you things on a secondary level, and it is much more effective. That's why I don't like shocking images. I prefer images to be like love songs, to be easy, you know, so you open yourself to them.

Brazilian literature, especially Portuguese literature, is an enormous influence. See, I've only given you schizophrenic references. The mind of the intellectual Brazilian in the '70s was trained to be schizophrenic. It was trained to absorb many things that weren't represented, many things that were in 19th-century Portuguese literature or early 20th-century, like, for instance, Pessoa.

LBJ: Fernando Pessoa? The writer with multiple pen names?
VM: Yes. Fernando Pessoa is a great influence on my work. He was somebody who was not only schizophrenic, but aware and very organized as a schizophrenic. I think that's a wonderful position.

I didn't really look at Brazilian art very carefully until I was out of the country. Now I go back and I realize that there are a number of coincidences and a number of things that I share with artists from my country, not because I learned art the same way they did, but because I lived in the same time as they did. I find it interesting that when I decided I wanted to become a visual artist I was living in the United States. My references were mainly American and European. I was looking at European and American art through the eyes of a Brazilian person.

LBJ: Exactly. What you have just described as the layering of meaning in Brazilian music, art, and literature is also something that takes place in your visual images.

When we started talking the other day about when we would do this interview, I sensed a certain *saudade* on your part because you said, "We'll do it in the Brazilian way," and I wondered if you could explain that?
VM: It means very late, you know, when there is really no other way to do it, like you have to do it, so that's the Brazilian way. You cannot procrastinate any more. That's Brazilian. I work like that.

LBJ: Is *saudade* a word that Brazilians use? It's a central concept in Portugal.
VM: Well, it's a word that there's no translation for. The closest thing is longing, but longing with pleasure. It's like thinking of a memory of somebody but thinking of the good things that person left with you.

LBJ: Vik, you may not know this, but many highly regarded photographers in the twentieth century came to Pittsburgh to make images: Lewis Hine, Margaret Bourke-White, Edward Weston, W. Eugene Smith, and Lee Friedlander. But here you are, the first one in the twenty-first century. How do you feel following in the footsteps of all these characters?
VM: That's a lot — you just created a situation which demands a lot of responsibility.

LBJ: It's a little intimidating, but I can make you feel better because actually what distinguishes you is that they all came — Alvin Langdon Coburn came too…
VM: Wow.

LBJ: … they came because Pittsburgh was such an important city in the history of this country.

VM: It's a pretty city.

LBJ: It's a pretty city and an ugly city at the same time in the sense that what made it pretty…

VM: Made it ugly.

LBJ: And what was ugly made it pretty, and it was all very entangled in that way. In fact, Coburn loved to come here because of the smoke, you know, from the steel mills.

VM: Yes. He didn't have to labor too much on those prints. They would have been foggy by themselves.

LBJ: That's right. And you are here not looking at the city, but you have a focus, Clayton, that's much more specific than any of them.

VM: Yes and no, because through the story of Clayton, you get to understand a lot about the story of the city, and also there's a little bit of that entanglement along with that. I mean, I understand the city of Pittsburgh now a lot better because of what I saw and what I read and what I researched at Clayton. Aside from that, it's one of the few cities in the United States where I feel I'm somewhere else. I have the feeling wherever I go it's always the same, apart from New York, San Francisco. It's almost like Pittsburgh could be a different country if you just, you know, let a few details go by.

Because of the geography and the architecture, there's something very specific about Pittsburgh that's interesting. I don't know many cities in the United States with geography as complex as Pittsburgh's. Maybe it's just that I haven't been around enough, but I have never seen so many bridges and overpasses and things. Because of so many rivers and so many levels, it's interesting and visually engaging. It's also the deep ravines — once you are down there, it's impossible to take a picture of the sky. It looks like the sky almost disappears unless you really point the camera straight up. I grew up in a place that was hilly and very far from the sea, so that may be something that I find comfort in.

LBJ: Pittsburgh is somewhat different from the places where you've shown your work in recent months: Paris, London, São Paulo, New York. What do you hope your new Pittsburgh audience will garner from your work?

VM: I try not to cater to specific audiences. I just hope the viewer is somebody who can be a child or an intellectual. I try to make work that's open enough to trigger some kind of train of thought in either one of these extremes.

LBJ: Will this experience nourish you in some way?

VM: Is there any experience that doesn't nourish you? I haven't had one.

Linda Benedict-Jones is Executive Director of Silver Eye Center for Photography in Pittsburgh, Pennsylvania.

BIBLIOGRAPHY

BORN

1961, São Paulo, Brazil

Lives and works in New York City

SOLO EXHIBITIONS

2001

The Things Themselves. Whitney Museum of American Art, New York, N.Y.

The Atlanta College of Art, Atlanta, Ga.

Museu de Arte Moderna, Rio de Janeiro, Brazil

Museu de Arte Moderna, São Paulo, Brazil

2000

Clayton Days. Frick Art & Historical Center, Pittsburgh, Pa.

Musée de l'Elysée Lausanne, Lausanne, Switzerland

Pictures of Ink. Brent Sikkema Gallery, New York, N.Y.

"Photographs" & Personal Articles. Ubu Gallery, New York, N.Y.

Gallery Gan, Tokyo, Japan

The Contemporary Museum, Honolulu, Hawaii

Foundation Huis Marseille, Amsterdam, The Netherlands

Vik Muniz. Tang Teaching Museum and Art Gallery, Saratoga Springs, N.Y.

The Invisible Object. Galeria Camargo Vilaça, São Paulo, Brazil

Earthworks. Rena Bransten Gallery, San Francisco, Calif.

1999

Center for Creative Photography, Tucson, Ariz.

Galeri Lars Bohman, Stockholm, Sweden

Gian Enzo Sperone Gallery, Rome, Italy

Photo & Co., Turin, Italy

Centre National de la Photographie, Paris, France

Flora Industrialis. Caisse des Dépôts et Consignations, Paris, France

Fresh Paint. Renos Xippas Gallery, Paris, France

The Contemporary Museum, Honolulu, Hawaii

Beyond the Edges. The Metropolitan Museum of Art, New York, N.Y.

Center for Creative Photography, Tucson, Ariz.

Museum of Contemporary Photography, Chicago, Ill.

1998

Galeria Módulo, Lisbon, Portugal

Seeing is Believing. International Center of Photography, New York, N.Y.

Flora Industrialis. Brent Sikkema Gallery, New York, N.Y.

Rena Bransten Gallery, San Francisco, Calif.

1997

Pictures of Thread. Wooster Gardens, New York, N.Y.

Galeria Camargo Vilaça, São Paulo, Brazil

Dan Bernier Gallery, Los Angeles, Calif.

1996

The Sugar Children. Tricia Collins Contemporary Art, New York, N.Y.

Galeria Casa da Imagen, Curitiba, Brazil

The Best of Life. Wooster Gardens, New York, N.Y.

Pantomimes. Rena Bransten Gallery, San Francisco, Calif.

1995

The Wire Pictures. Galeria Camargo Vilaça, São Paulo, Brazil

1994

Representations. Wooster Gardens, New York, N.Y.

1993

Equivalents. Tricia Collins Contemporary Art, New York, N.Y.

Equivalents. Ponte Pietra Gallery, Verona, Italy

1992

Individuals. Stux Gallery, New York, N.Y.

Claudio Botello Arte, Turin, Italy

1991

Gabinete de Arte Rachel Arnaud, São Paulo, Brazil

Galerie Claudine Papillon, Paris, France

1990

Meyers/Bloom Gallery, Santa Monica, Calif.

Stephen Wirtz Gallery, San Francisco, Calif.

1989

Stux Gallery, New York, N.Y.

SELECTED GROUP EXHIBITIONS

2000

2000 Biennial Exhibition. Whitney Museum of American Art,
New York, N.Y.

Photo España 00. Galeria Elba Benitez, Madrid

Landscape-Portrait. Michael Hue-Williams Fine Art, London, UK

The Corcoran Biennial. The Corcoran Gallery of Art, Washington, D.C.

The Quiet of the Land. Museu de Arte Moderna, Salvador, Brazil

*Expanding Horizons: Landscape Photographs from the Whitney Museum of American
Art.* Whitney Museum of American Art at Philip Morris, New York,
N.Y.

1999

The Museum as Muse: Artists Reflect. The Museum of Modern Art,
New York, N.Y.

Abracadabra. The Tate Gallery, London, UK

Trace. The Tate Gallery, Liverpool, UK

1998

XXIV Bienal Internacional de São Paulo. São Paulo, Brazil

Group Exhibition. The Cannon Gallery for Photography, The Victoria and
Albert Museum, London, UK

Urban Cannibal. Paço das Artes, São Paulo, Brazil

Double Trouble, the Patchett Collection. Museum of Contemporary Art,
San Diego, Calif.

Le Donné, le Fictif. Centre National de La Photographie, Paris, France

The Garden of the Forking Paths. Kunstforeiningen, Copenhagen, Denmark,
traveled to Oslo, Norway; Helsinki, Finland

Over Our Heads: The Image of Water in Contemporary Art. San Jose Museum of
Art, San Jose, Calif.

Coleção Gilberto Chateaubriand/Museu de Arte Moderna do Rio de Janeiro. Haus der
Kulturen der Welt, Berlin, Germany

Das Mass der Dinge. Ursula Blickle Stiftung, Kraichtal, Germany; Galerie Im
Traklhaus, Saltzburg, Austria

The Cottingley Fairies and Other Apparitions. The Brooks Museum of Art,
Memphis, Tenn.

La Collection II. Fondation Cartier pour l'art contemporain, Paris, France

Internality Externality. Galerie Lelong, New York, N.Y.

1997

New Photography XIII. The Museum of Modern Art, New York, N.Y.

New Faces and Other Recent Acquisitions. The Art Institute of Chicago,
Chicago, Ill.

Assi Esta la Cosa. Centro Cultural Arte Contemporaneo, Mexico DF,
Mexico

Une Fleur des Photographes: L'Arum. Musée National de la Coopération
Franco-Américaine, Château de Blérancourt, Blérancourt, France

Pool. Rena Bransten Gallery, San Francisco, Calif.

One Line Drawing. UBU Gallery, New York, N.Y.

Collección Ordóñez Falcón de Fotografía. IVAM Centre Julio Gonzalez,
Valencia, Spain

Artistes Latino-Americains. Daniel Templon, Paris, France

20 Years, Almost. Robert Miller Gallery, New York, N.Y.

Hope. The National Arts Club, New York, N.Y.

Ut Scientia Pictura. Paolo Baldacci Gallery, New York, N.Y.

1996

Wesenchau: Disingenuous Images. Galerie Renee Ziegler, Zurich, Switzerland

Bis. Galeria Camargo Vilaça, São Paulo, Brazil

The Subverted Object. UBU Gallery, New York, N.Y.

Recent Acquisitions. The Metropolitan Museum of Art, New York, N.Y.

Inclusion/Exclusion. Steirischer Herbst, curated by Peter Weibel, Graz,
Austria

Some Assembly Required. The Art Institute of Chicago, curated by David
Travis (three photographers), Chicago, Ill.

Novas Aquisições. Coleção Gilberto Chateaubriand, Museu de Arte
Moderna, Rio de Janeiro, Brazil

Shadow Play. San Jose Institute of Contemporary Art, San Jose, Calif.

Material Matters. A.O.I. Gallery, Santa Fe, N. Mex.

1995

Changing Perspectives. Contemporary Art Museum, Houston, Tex.

Panorama da Arte Contemporânea Brasileira. Museu de Arte Moderna, curated
by Ivo Mesquita, São Paulo, Brazil; Rio de Janeiro, Brazil

Mostra America. Fundação Cultural de Curitiba, curated by Paulo
Herkenhoff, Curitiba, Brazil

Recent Acquisitions. Los Angeles County Museum, Los Angeles, Calif.

The Photographic Condition. San Francisco Museum of Modern Art,
San Francisco, Calif.

The Cultured Tourist. Center For Photography at Woodstock, curated by
Leslie Tonkonow, Woodstock, N.Y.

Blindspot. The MAC, Dallas Artist Research and Exhibition, Dallas, Tex.

Garbage. Thread Waxing Space, New York, N.Y.

1994

Single Cell Creatures. Katonah Museum of Art, Katonah, N.Y.

Crash. Thread Waxing Space, New York, N.Y.

Up the Stablishment: Reconstructing the Counterculture. Sonnabend Gallery, curated
by Dan Cameron, New York, N.Y.

Garbage. Real Art Ways, curated by Ann Pasternak, Hartford, Conn.

Jetleg. Gallerie Martina Detterer, Frankfurt, Germany

1993

Tom Cugliani Gallery, New York, N.Y.

The Alternative Eye: Photography for the '90s. Southern Alleghenies Museum,
Loreto, Pa.

Time to Time. Castello di Rivara, curated by Luca Beatrice, Torino, Italy

Sound. Museo d'Arte Moderna, Bolzano, Italy

Post-Verbum. Pallazzo della Regione, Bergamo, Italy

1992

Life Size: Small, Medium, Large. Museo d'Arte Contemporanea Luigi Pecci, Prato, Italy

Multiples. The Aldrich Museum of Art, Ridgefield, Conn.

Detour. The International House, New York, N.Y.

The Collection. Centro per l'Arte Contemporanea Luigi Pecci, Prato, Italy

Les Enfants Terribles. Wooster Gardens, New York, N.Y.

Gallery Artists. Galerie Claudine Papillon, Paris, France

Theoretically Yours. Regione Autonoma Della Valle d'Aosta, Aosta, Italy

1991

Mike Kelley/Vik Muniz/Jim Shaw. Real Art Ways, Hartford, Conn.

The Encompassing Eye, Photography as Drawing. University Art Galleries, University of Akron, Ohio

The Neighborhood. A.I.R., Amsterdam, The Netherlands

Anni Novanta. Galleria d'Arte Moderna, curated by Renato Barilli and Pier Giovanni Castagnoli, Comune di Bologna, Italy

Real Fake. Fondation Cartier pour l'art contemporain, Paris, France

Outside America. Fay Gold Gallery, Atlanta, Ga.

The Fetish of Knowledge. Real Art Ways, Hartford, Conn.

1990

Non Sculpture. Galerie Barbara Farber, Amsterdam, The Netherlands

Constructed Illusion. Pace MacGill Gallery, New York, N.Y.

Assembled. Wright State University, Dayton, Ohio

On the Edge Between Sculpture and Photography. Cleveland Center for Contemporary Art, Cleveland, Ohio

1989

De Rozeboomkamer. Beeldenroute Foundation, Diepenheim, Holland

Wortlaut: Konzepte Zwischen Visueller Poesie & Fluxus. Galerie Schuppenhauer, Cologne, West Germany

SELECTED BIBLIOGRAPHY

Anton, Saul. "Your 15 Minutes Are Up: Vik Muniz Pops Pop's Balloon." Time Out New York May 2000.

Alleti, Vince. "Constructed Illusions." The Village Voice 20 Nov. 1990.

---. "Choices." The Village Voice 21 March 1995.

---. "Choices." The Village Voice 3 Dec. 1996.

---. "Organized Confusion." The Village Voice 2 Dec. 1997.

---. "Choices." The Village Voice 29 Sept. 1998.

---. "For Muniz, The Medium is the Message." The Village Voice 23 May 2000.

Baker, Kenneth. "Eccentric and Entertaining Pieces." The San Francisco Chronicle 7 April 1990.

---. "Muniz Whets the Appetite for Images in Chocolate." The San Francisco Chronicle 16 April 1998.

Bonetti, David. "The Inevitability of Vik Muniz." San Francisco Examiner 6 April 1990.

---. "Vik Muniz at Rena Bransten." San Francisco Examiner 10 May 1996.

Cotter, Holland. "Three Shows Celebrate the Spirit of Fluxus." The New York Times 23 Oct. 1992.

---. "200 Images Leisurely Chatting." The New York Times 31 Jan. 1997.

---. "New Photography 13." The New York Times 7 Nov. 1997.

Crosby, David. "Vik Muniz." Zoom Feb. 1999.

Decter, Joshua. "Vik Muniz." exhibition catalogue essay, Stux Gallery, New York. 1989

---. "Vik Muniz at Stux." Arts Magazine March 1989.

Dowell, Bill. "A Postmodern Photographer Who is Reshaping His Medium." Time Magazine International 24 May 1999: *Latin American Leaders for the New Millennium* issue.

Faust, Gretchen. "Vik Muniz." Arts Magazine May 1990.

Finkel, Jori. "Vik Muniz: Photographs." On Paper July/Aug. 1998.

Fortes, Marcia. "XIV São Paulo Biennial." Frieze Feb. 1999.

Gallo, Ruben. "Aperto Brazil." Flash Art Oct. 1998.

Goldberg, Vicky. "Of Fairies, Free Spirits and Outright Frauds." The New York Times 1 Feb. 1998: weekend section, front page.

---. "It's a Leonardo? It's a Corot? Well, No, It's Chocolate Syrup." The New York Times 25 September 1998: weekend section.

Grundberg, Andy. "Seeing is Believing." The New York Times Book Review 6 Dec. 1998.

---. "Sweet Illusion." Artforum September 1997.

Hagen, Charles. "Mixing Humor with the History of Photography." The New York Times 24 March 1995.

---. "Vik Muniz." The New York Times 5 February 1993.

---. "The Encompassing Eye: Photography as Drawing." Aperture Fall 1992.

Hirsch, Faye. "Rethinking Genres in Contemporary Photography." Art on Paper Jan. 1999.

Holliday, Taylor. "Vik Muniz: A Closer Look, Some Second Thoughts." The Wall Street Journal 20 Oct. 1998.

Huitorel, Jean-Marc. "Life Size." Art Press Oct. 1992.

---. "Photographie d'une Collection." Caisse des Dépôts et Consignations/Hazan, Paris, France.

Jacques, Alison Sarah. "Life Size." exhibition catalogue essay, Luigi Pecci Museo per l'Arte Contemporanea, Italy: 1992.

Jouannais, Jean Yves. "Vik Muniz." Art Press December 1991.

Kahn, Wolf. "Connecting Incongruities." Art in America November 1992.

Katz, Vincent. "Vik Muniz at Brent Sikkema." Art in America December 1995.

Kismarik, Susan. "Vik Muniz: New Photography 13." MoMA Magazine Fall 1997.

Kandel, Susan. "Artful Illusions and Serial Masquerades Spring to Life." Los Angeles Times 4 April 1997.

Kurjakovik, Daniel. "Wesenchau." Kunst Bulletin January 1997.

Leffingwell, Edward. "Through a Brazilian Lens." <u>Art in America</u> April 1998.

Levin, Kim. "Choices." <u>The Village Voice</u> 2 April 1991.

---. "Vik Muniz: In Brief." <u>The Village Voice</u> 16 February 1993.

Lieberman, Rhonda. "Stuttering." <u>Flash Art</u> April/May 1991.

---. "Traumatic Objects: There's No Place Like Home." exhibition catalogue essay, Gabinete de Arte Raquel Arnaud, São Paulo, Brazil: August 1991.

---. "Vik Muniz at Stux." <u>Arts Magazine</u> January 1990.

Linfield, Susan. "Sweet Deception." <u>Art News</u> February 1999.

Mahoney, Robert. "Vik Muniz: Sugar Children." <u>Time Out New York</u> 19 Dec. 1996.

Markham, Pamela. "The Compleat Vik Muniz." <u>Review</u> 15 Oct. 1998.

Melrod, George. "Vik Muniz: Stux Gallery, New York." <u>Sculpture</u> Nov./Dec. 1990.

Mesquita, Ivo. "Panorama da Arte Contemporânea Brasileira." exhibition catalogue essay, Museu de Arte Moderna, São Paulo, Brazil: November 1995.

Millazo, Richard. "Vik Muniz: The Wrong Logician." exhibition catalogue essay, Grand Salon, New York and Ponte Pietra, Verona, Italy: October 1993.

Miller, Kenneth. "Sugar Snaps." <u>Life Magazine</u> March 1998.

Perela, Christina. "Vik Muniz." <u>Tema Celeste</u> Italian ed. Fall 1992.

Princenthal, Nancy. "Vik Muniz at Stux." <u>Art in America</u> April 1989.

Ramade, Benedict. "Vik Muniz." <u>Parachute</u> 98 (2000).

Rosenburg, Barry. "Assembled." exhibition catalogue essay, Cleveland Center for Contemporary Art, Cleveland, Ohio: April 1990.

Scott, Whitney. "Must Museum." <u>The New York Post</u> 15 Oct. 1997.

Senft, Bret. "Vik Muniz: Low-Tech Illusionist." <u>Photo District News</u> Oct. 1998.

Shales, Ezra. "Vik Muniz." <u>Review Magazine</u> 1 Dec. 1996

Siegel, Katy. "Vik Muniz." <u>Artforum</u> Dec. 1998.

Smith, Roberta. "Art in Review." <u>The New York Times</u> 13 Dec. 1996.

---. "Spring Fireworks for an Old Hub." <u>The New York Times</u> 5 May 2000.

Tager, Alisa. "Detour." exhibition catalogue essay, The International House, New York: May 1992.

Tsai, Eugene, "Force of Nature." <u>Artnews</u> May 1999.

Vescovo, Marisa. "Vik Muniz a Torino." <u>La Stampa</u> 27 April 1992.

---. "Post Verbum." <u>Tema Celeste</u> June 1993.

---. "Sound, Forme e Colore del Suono." exhibition catalogue essay, Museum fur Modern, Kunst-Bozen: 1993.

Wallis, Stephen. "Photo Opportunity." <u>Art and Antiques</u> September 1998.

Wegman, Virginia. "Work of Noted Photographer is About Image." <u>The Honolulu Advertiser</u> 13 Feb. 2000.

Weibel, Peter. "Inclusion Exclusion." exhibition catalogue essay, Kunstlerhaus, Austria: 1997.

Wilson, Beth. exhibition catalogue essay, Stux Gallery, New York: Oct. 1989.

SELECTED PUBLIC COLLECTIONS

The Museum of Modern Art, New York

The Metropolitan Museum of Art, New York

The National Museum of American Art, Smithsonian Institution, Washington, D.C.

The International Center of Photography, New York

The Whitney Museum of American Art, New York

New York Public Library

The Museum of Fine Arts, Boston

The Art Institute of Chicago

The Museum of Contemporary Art, Chicago

San Francisco Museum of Modern Art

The Aldrich Museum of Contemporary Art, Ridgefield, Conn.

Los Angeles County Museum, Los Angeles

Los Angeles Museum of Contemporary Art, Los Angeles

The San Diego Museum of Contemporary Art, San Diego, Calif.

The San Jose Museum of Art, San Jose, Calif.

The Victoria and Albert Museum, London

The Contemporary Museum of Honolulu, Hawaii

The Norton Family Foundation, Santa Monica, Calif.

The Bohen Foundation, New York

Fondation Cartier pour l'art contemporain, Paris

The MacArthur Foundation, Chicago

Caisse des Dépôts et Consignations, Paris

La Maison Européenne de la Photographie, Paris

IVAN Centre Julio Gonzales, Valencia, Spain

Israel Museum, Jerusalem

Museu de Arte Moderna, Rio de Janeiro, Brazil

Museu de Arte Moderna de São Paulo, Brazil

Dallas Museum of Art, Texas

Modern Art Museum of Fort Worth, Texas

The Museum of Fine Arts, Houston, Texas

Museo de Arte Contemporanea Luigi Pecci, Prato, Italy

Roseum, Malmo, Sweden

The Progressive Corporation, Mayfield Village, Ohio

Reader's Digest, Pleasantville, New York

Prudential Foundation, Newark, New Jersey

Many thanks

by VIK MUNIZ

I AM ENDLESSLY GRATEFUL TO ALL OF THE PEOPLE who were involved in the Frick project from beginning to end. I would especially like to thank my assistant Cleverson de Oliveira for his dedication, hard work, and calm disposition. The members of the staff listed below who participated in the sometimes lengthy photo sessions were always enthusiastic to try one more, even while dressed in wool in 80 degree weather. I would also like to thank Dick McIntosh, Linda Benedict-Jones, and Andy Grundberg for inviting me to participate in the residency. It has been an honor to work with such kind, professional, and supportive people. And finally, I am truly indebted to Sherrie Flick for managing the ever-expanding project with such grace and wit.

ADULTS IN PHOTOGRAPHS:

Rose Ehler (fancy adolescent woman)

Sam Ferrara (fancy guy)

Sherrie Flick (maid)

Sarah Hall (fancy woman with baby)

Cynthia Lackey (fancy woman)

Jeffrey Livesee (chauffeur)

Molly Morrill (fancy adolescent woman)

Vik Muniz (photographer)

Cleverson de Oliveira (hobo, brawl, slag heap, mirror)

Coke O'Neil (snake killer, pony guy)

Don Ossler (fancy guy)

Jennifer Roche (fancy woman)

Rick Schweikert (brawl, tease, fancy guy, promenade)

Tom Smart (doctor, bike rider, fancy guy)

Pam St. John (maid)

Jillian Wein (fancy adolescent woman)

Laura Wenneker (fancy woman)

Paul Wiegman (car passenger)

Pam Wiegman (car passenger)

CHILDREN IN PHOTOGRAPHS:

Will Acer (pony rider, pet burial)

Anna Calabrese (dog, pet burial, hoops, pony)

Louisa Fitzgerald (bubbles, frog)

Nathaniel Gruzska (baby)

Willy Morrill (under bed)

Chloe Regan (girl with doll, pet burial, hoops)

Adrian Smart (window, hide-and-seek)

Sacha Smart (snake killer's assistant, hide-and-seek, pet burial, pony leader)

COSTUMES:

Sherrie Flick

Robin Pflasterer

Pam St. John

AND SPECIAL THANKS TO:

Dede Acer

Susan Bails

Erika Benincasa

Gini Calabrese

Terri Chapman

Sylvia Fein-Ehler

Sarah Hall

Kathy Kendra

Greg Langel

Kirsten Liddicoat

Faye Mansfield

Pat McShea

Louise Mitinger

Mary Navarro

Earl Nixon

Jennifer Roche

Anne-Marie Russell

Rania's Catering

Laura Schoch

Tom Smart

Marion Tandé

Jessica Ullery

Laura Wenneker

John Wolfendale

BRENT SIKKEMA GALLERY:

Brent Sikkema

Michael Jenkins

CHELSEA BLACK AND WHITE:

Karen Crumley (Toning)

Megan Maloy (Toning)

Michael Amoruso (Printing)

*C*OLOPHON

This book was designed by Kendra Power Design & Communication, Pittsburgh, Pennsylvania.

The book was printed by The Stinehour Press, Lunenburg, Vermont,

and bound by Acme Bookbinding of Charlestown, Massachusetts.

The text is set in Centaur, an early 20th-century typeface. The catalogue is printed on

Sappi Lustro Dull Cream with Gilbert Gilclear.